Drawing
Problems and Solutions

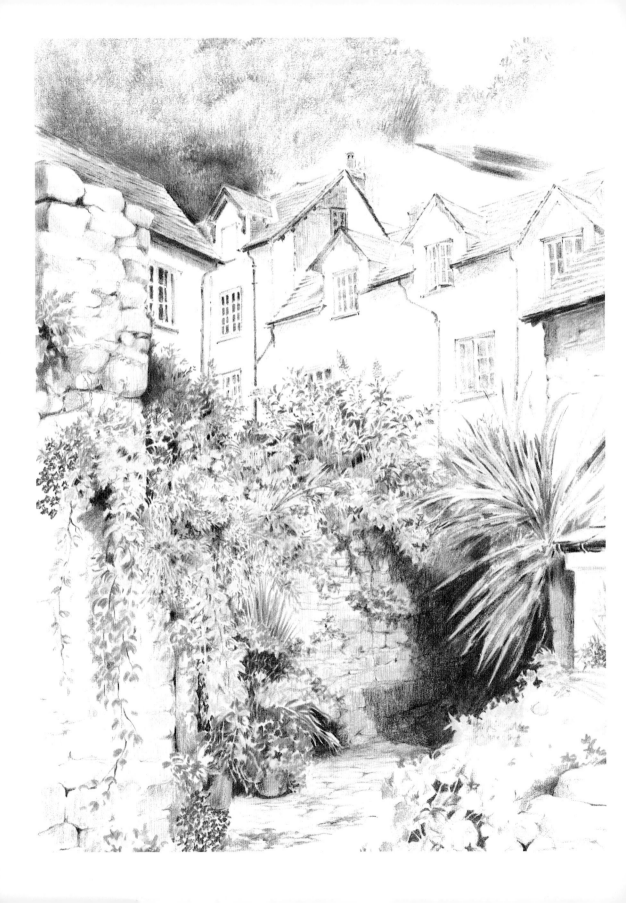

Drawing
Problems and Solutions

Trudy Friend

NORTH LIGHT BOOKS
Cincinnati, Ohio

To Michael

A DAVID & CHARLES BOOK

First published in North America
in 2001 by North Light Books
an imprint of F&W Publications, Inc
1507 Dana Avenue
Cincinnati, OH 45207
(800) 289-0963

First published in the UK in 2001

ISBN 1-58180-202-1

Printed in Italy by Lego SpA
for David & Charles
Brunel House Newton Abbot Devon

Publishing Manager: Miranda Spicer
Commissioning Editor: Anna Watson
Art Editor: Diana Dummett
Desk Editor: Freya Dangerfield

This book is based on Trudy Friend's popular 'Problems and Solutions' series in
Leisure Painter magazine. For subscription details and other information, please contact:
The Artists Publishing Company Ltd, Caxton House, 63–5 High Street, Tenterden, Kent TN30 6BD,
Tel: 01580 763315, Fax: 01580 765411, www.leisurepainter.co.uk

Contents

Introduction

With this book I will be helping you …
to love your art,
to live your art
and see the world go by
as colour, texture, line and form
and with an 'artist's eye'.

This book is intended to help beginners who, inspired by a subject, are unsure where or how to put marks in order to create a recognizable impression on paper or card.

Many beginners try to copy exactly what they see, whether from a photograph (if they cannot work from life) or something set in front of them, as with still-life or flower studies. When presented with a distant view this can be very daunting. You may be unaware that it is not only what you put into your drawing, but what you choose to leave out, that is important. You may find it difficult to be selective.

In this book there are 12 themed sections about different subjects. Each contains some typical learner's mistakes on one page, with suggested methods to overcome these problems on the facing page. The most important advice, however, is to remember the three 'P's that are essential for all beginners – Practice, Patience and Perseverance.

Practice
If you can find time on a daily basis (even if only ten minutes) to practise a few marks, you will be learning. Try looking closely at your surroundings and drawing small details and studies rather than always thinking of making a picture. Sometimes just practise making marks for their own sake – these 'constructive doodles' can be invaluable.

Patience
Patience is an extremely important aspect of learning to draw. By this I mean patience with yourself, at the stage you have reached so far. Try not to compare your present level of achievement with that of others, even if they are beginners too. You are being very unfair to yourself if you judge your efforts too harshly. Self-criticism is an important part of learning, but do beware of putting yourself down. Use constructive criticism, but try to acknowledge that you may need to be told, shown and have things explained in detail in order to understand. This is all part of the natural learning process.

Perseverance and pride
When explaining perseverance, I refer to the fact that we all experience low periods – times when everything seems to go wrong for us. This may be easier to accept when it is related to everyday life, but it will occur with your artwork as well. It happens to us all at some time, whatever level we have achieved, but it probably seems worse to a beginner. So persevere and try not to become despondent. If you have a bad art day leave your drawing for a while, or perhaps just practise making marks, returning to it later with a fresh eye. In many cases this is all that is required in order for your progress to continue.

You should always take a pride in the way you prepare your drawing materials and your work surface. If you do not wish to invest in a table easel, obtain a rigid piece of plywood approximately 35 x 48 cm (14 x 19 in) and raise it to an angle from the table with the aid of books or a block of wood. Ensure this is stable and will not move.

Erasing

I do not advocate the use of an eraser when trying out the exercises in this book. It is of greater benefit to you to see your mistakes – and how you correct them – rather than by erasing an error that may inadvertently be made again in the same place. Sometimes a drawing is more exciting when we are able to see the artist's original lines and how they have been changed and corrected throughout the work. This method also encourages the use of varied pencil pressure on the paper's surface, as the image can be suggested by light pressure at first (with 'wandering' lines) over which more pressure is asserted on subsequent lines, until the final, contrasting tones bring it to life.

Techniques

A number of specific drawing techniques are referred to and are illustrated throughout the book; these are incorporated to give you confidence to make marks on paper without even intending to erase any mistakes, and allowing you literally to 'feel' your way across your drawing as you progress.

Beginners may find it difficult to understand that we are able to make marks on the paper that express what we feel about what we see, as well as what we actually see. In addition to this, we may choose to build the drawing upon marks that are made very lightly on the paper and are subsequently changed and corrected, yet all are left in place throughout the drawing, as mentioned above.

Perhaps surprisingly, we do not always require lines in order to establish form. Instead, learn to think of drawing in a 'painterly' way, that is, being more concerned with tonal blocks and their relationships than with pure linear drawing. The exercises in this book also bring in the importance of drawing light against dark (or 'dark behind'), for instance by illustrating a solid object with dark massed foliage behind and shadow area on grass at the base.

To take one example, the demonstration on page 17 brings a number of techniques into consideration. It uses 'directional' strokes that describe the form – think of these as 'finding out' lines, as they enable you to find out the shape of the form. A continuous heavy line, applied with a zigzag movement, gives the impression of a mass radiating from a central area. Flat areas of tone suggest a backdrop and the surface on which the subject rests.

This drawing also gives you opportunities to show reflected light on curved surfaces by shading an intensely dark area a little away from the shadow side of the form. In addition, in this drawing there are lines that 'follow the form' as well as tonal lines and 'lost' lines. A 'lost' line is an area where the subject is the same tone as its background, therefore no mark is made on the paper at that point.

Developing a personal style

You can follow the solutions pages to draw familiar subjects that perhaps you have not studied closely before. Then try others, of your own choice, giving them the same amount of care and consideration.

Everyone sees things differently, and each artist has their own personal approach. Transformation takes place by understanding the subject, its structure and the best way of depicting it. Trial and error studies will help you discover how to 'see' the subject and how to portray it to your own satisfaction.

Drawing Materials

You can draw with anything that will make a mark on any suitable surface that will take a mark. Whatever you decide to use, spend some time just making marks and becoming familiar with using your art materials. The marks below are made with materials used for the exercises throughout the book, and show just a few of the endless possibilities.

If you are using a pencil you must be able to sharpen it properly, and the illustration opposite shows you how to do so to best effect. Once it is sharpened you can shape the point to a chisel edge, useful for producing a 'tonal mass' or range of tones.

Choose your materials to suit your subjects. Page 10 shows a variety of effects that can be achieved with different types of coloured pencils. In certain instances – for example, when using soft pencil or charcoal – you will need to fix the medium by using a fixative spray or diffuser, which can be obtained from an art shop.

Some media may fade in the sunlight, while others may crumble off the surface you have chosen, if unsuitable. Make sure, therefore, that you use use good quality materials that will 'work' well upon the chosen support, be it paper, card or board. Consider the texture of the paper carefully, too.

For practice, however, beginners will find that a pack of copier paper from an office shop and a couple of good pencils will afford many hours of constructive doodling and 'trial and error' studies.

Pencils and pens

Graphite pencils are available from 9H (the hardest 'lead') to 9B (the softest), with H, HB and B in mid-range. Profipens can be used to make strong linear marks.

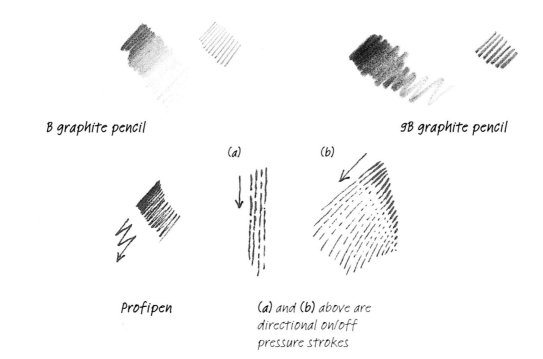

B graphite pencil

9B graphite pencil

(a) *(b)*

Profipen

(a) and (b) above are directional on/off pressure strokes

How to sharpen a pencil

The best tool for sharpening pencils is a utility knife rather than a pencil sharpener or craft knife. The aim is to create a good point by angling the blade to such an extent that it glides over the wood. Try to remove slivers rather than chips.

Pull the pencil towards the blade

The hand holding the knife does nothing else. It just holds the knife to allow the other hand to operate. This, and the acute angle at which the knife is held, prevents the blade cutting into the wood too sharply and removing too much wood with the stroke

Turn the pencil as it is being sharpened (imagine that you are trying to roll a small piece of tissue between your finger and thumb). This turning movement is to ensure even sharpening

How to use the pencil

If you learn when to turn the pencil while you are working (with practice this will become a natural habit), you can use just one pencil, turned as necessary, for areas of contrasting tonal and linear application, without having to sharpen it repeatedly.

The point created on the opposite side of the lead will be sharp enough to draw very fine lines

By making a number of strokes with a soft pencil, the lead will wear down to a chisel shape. The more you apply, the wider the chisel shape becomes and the more surface area is covered by each stroke. This will allow you to tone areas rapidly with side-by-side strokes

Coloured pencils

Modern coloured pencils are available in many different forms: standard, water-soluble, thick- and thin-leaded, and pastel pencils. They produce a wide variety of expressive marks which can be used in your work – see below for a selection of these.

Studio-quality coloured pencils

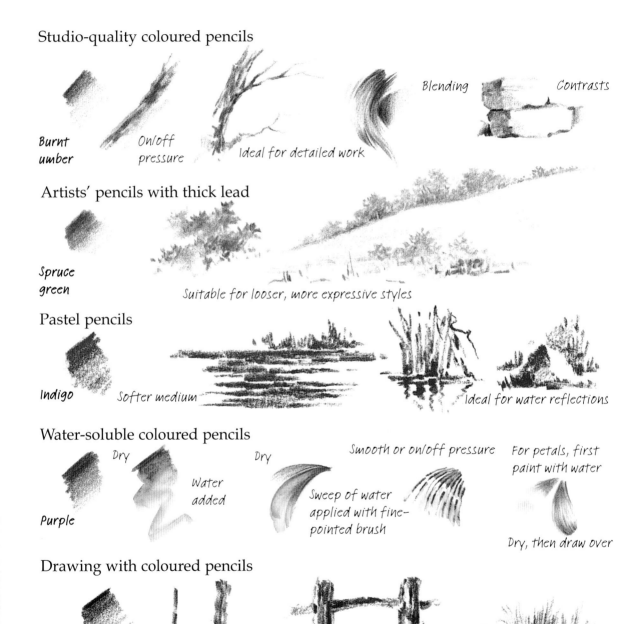

Burnt umber *On/off pressure* *Ideal for detailed work* *Blending* *Contrasts*

Artists' pencils with thick lead

Spruce green *Suitable for looser, more expressive styles*

Pastel pencils

Indigo *Softer medium* *Ideal for water reflections*

Water-soluble coloured pencils

Dry *Dry* *Smooth or on/off pressure* *For petals, first paint with water*

Water added *Sweep of water applied with fine-pointed brush*

Purple *Dry, then draw over*

Drawing with coloured pencils

Chocolate *Soft, creamy texture is ideal for tonal work*

Using textured surfaces

Using drawing surfaces that are textured can add an extra dimension to your work, particularly in landscape subjects. You can buy offcuts or sample swatches of paper or card from art shops, and practise creating textures on these.

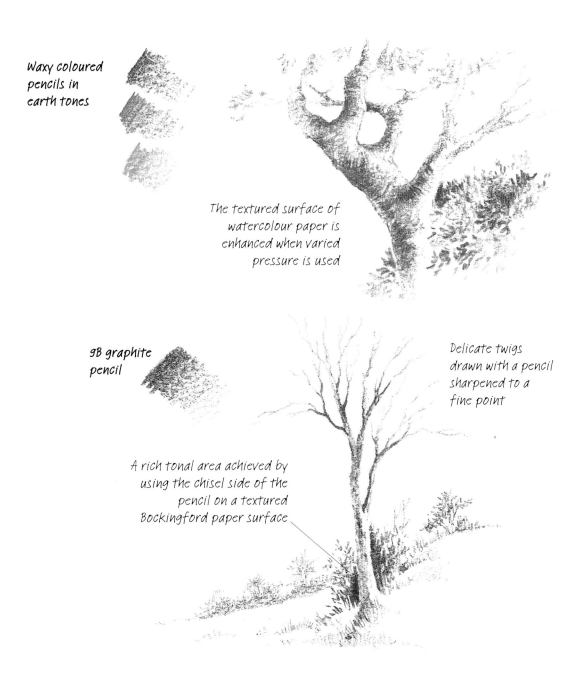

Waxy coloured pencils in earth tones

The textured surface of watercolour paper is enhanced when varied pressure is used

9B graphite pencil

Delicate twigs drawn with a pencil sharpened to a fine point

A rich tonal area achieved by using the chisel side of the pencil on a textured Bockingford paper surface

Constructive Doodles

In the rush to produce 'complete' drawings, it is all too easy to forget the importance of the basic marks you are using. Constructive doodles can be made any time you have a pencil and paper – try them to learn how to use simple marks to create complex effects.

Gently touch Press and travel Gently lift

One stroke from left to right

Gently touch – press more firmly – lift

One stroke across – return immediately (covering the first line), widening the central area

This effect is created by a series of down strokes with varying pressure

Gently touch

Press and travel

Lift, but remain in contact as you continue to travel

Re-assert pressure

Gently lift off

Try different strokes in a variety of directions, always varying pressure and maintaining contact with the paper

Varying pressure

Use simple, constructive doodle marks to draw a hank of hair with tight bands at intervals along its length. The darkest area will be near the bands, and light between them.

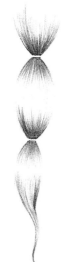

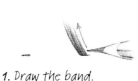

1. Draw the band.

2. Holding the pencil in an upright position, push stroke out from band.

3. Use 'directional' strokes to describe the form with firm pressure near the band, flicking up and away.

Practising doodles

All these exercises need to be practised again and again to improve your skill and techniques. Analyse your work and ask yourself questions such as 'Why does that line appear too heavy?' The answer may be as simple as needing to sharpen your pencil. Repeat the exercises, applying them to different subjects, and remember the three 'P's.

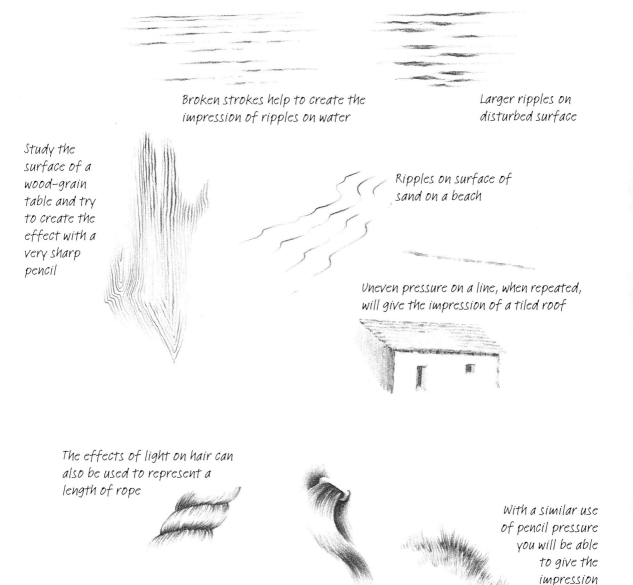

Broken strokes help to create the impression of ripples on water

Larger ripples on disturbed surface

Study the surface of a wood-grain table and try to create the effect with a very sharp pencil

Ripples on surface of sand on a beach

Uneven pressure on a line, when repeated, will give the impression of a tiled roof

The effects of light on hair can also be used to represent a length of rope

With a similar use of pencil pressure you will be able to give the impression of grass

Using a 'Wandering Line'

'Wandering lines' is a phrase that describes purely linear marks on paper or card, which are created by placing the tip of a sharpened pencil on to paper and using even pressure to create a line or shape. Because this is light, it can be treated as a starting point, and can then be strengthened or added to by other techniques, as in the exercise below.

1. Don't lift your pencil from the surface of the paper until you have drawn a number of stones of varying shapes and sizes. This will give the impression of a section of a stone wall.

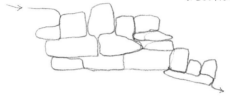

2. To strengthen your line, look for shapes between the stones, either as shadow shapes or shadow lines, and fill in with a dark tone.

3. With repeated up-and-down strokes, starting from the top of each stone on the top of the wall, create a medium to dark tonal mass.

4. Once you have placed this dark tone behind the top stones, fan out slightly with lighter pressure.

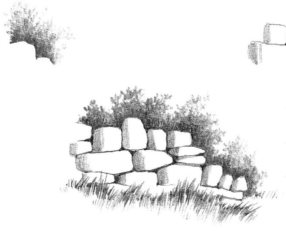

5. Create a shadow side to the stones by downward strokes applied with lighter pressure using a chisel-shaped lead.

Varying Pencil Pressure

In the exercise opposite, the unvarying pressure of the wandering line was added to by subsequent toning and shading. Where there will be no background for a study, you can reduce pressure on the pencil at certain points and increase it at others to avoid a hard, diagrammatic outline that may flatten the effect of your work.

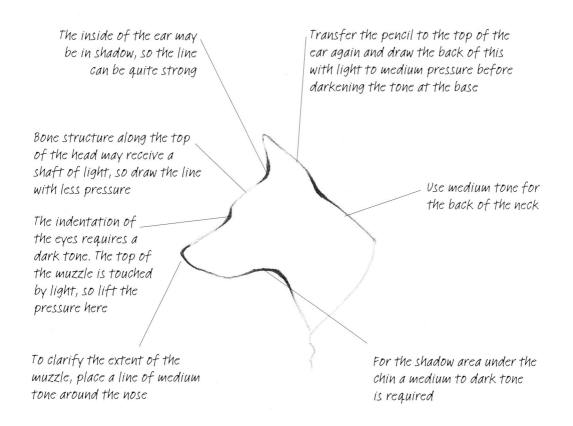

The inside of the ear may be in shadow, so the line can be quite strong

Transfer the pencil to the top of the ear again and draw the back of this with light to medium pressure before darkening the tone at the base

Bone structure along the top of the head may receive a shaft of light, so draw the line with less pressure

Use medium tone for the back of the neck

The indentation of the eyes requires a dark tone. The top of the muzzle is touched by light, so lift the pressure here

To clarify the extent of the muzzle, place a line of medium tone around the nose

For the shadow area under the chin a medium to dark tone is required

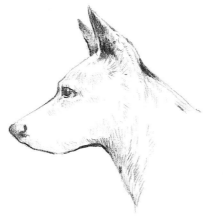

Add an eye and nose and a few lines to suggest hair that follows the form, and you have drawn a dog's head rather than a diagram of one.

Drawing in a 'Painterly Way'

Making linear marks and wandering lines is fine for depicting subjects lit by a fairly regular, even source. But there will be times when you want to suggest sharp contrasts, and creating tonal areas from the start, as painters do, can be the answer.

1. Use freely applied up-and-down strokes to establish a tonal area to represent the shadow side of a post.

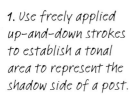

2. Neaten the edges and pull down a few uneven strokes at the base. Leave white paper for the sunlit side before shading the dark foliage at the top of the post.

3. Contiinue building up the foliage using upward and outward movements – use firmer pressure for more intensive tone behind the light side. Use the chisel side of the lead with short strokes to suggest delicate foliage areas.

4. Using the sharp side of the lead, create fine lines for twigs and delicate grasses.

Upward movements suggest dark grasses

Leave light areas to suggest light grasses in front of those in shadow

Directional Strokes

Once you have described the outline of an object using a wandering line, you can use purely linear strokes to give it form. In this exercise, all the outlines used to draw the mushroom are absorbed into its tonal areas to finish the piece.

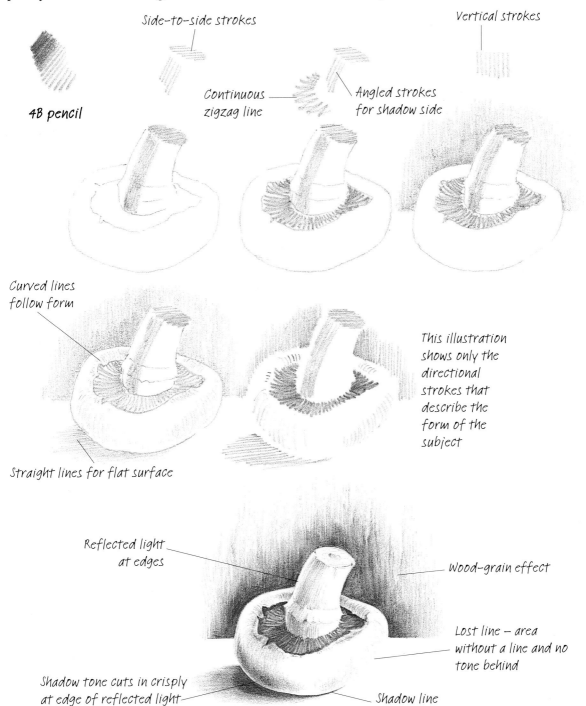

Side-to-side strokes

Vertical strokes

4B pencil

Continuous zigzag line

Angled strokes for shadow side

Curved lines follow form

This illustration shows only the directional strokes that describe the form of the subject

Straight lines for flat surface

Reflected light at edges

Wood-grain effect

Lost line – area without a line and no tone behind

Shadow tone cuts in crisply at edge of reflected light

Shadow line

Trees and Woodland

Drawing trees and woodland or forests creates its own particular problems. 'You can't see the trees for the wood' would sum up many of the pitfalls you can experience when trying to differentiate one tree from others, let alone finding out how to suggest the rest of the trees in the scene.

I often use a soft-grade pencil, 6B or 8B, when drawing trees. After a chisel shape has been created, the flat side of the lead quickly covers the shadow side of the tree when I apply up-and-down strokes. By turning the pencil round to the sharper point, you can use a delicate and interesting line to define the light side of the trunk.

You can switch to a harder-grade pencil, such as a 2B, to produce directional strokes on exposed roots, and to make a wandering line that establishes form for any part of your subject. The softer marks made by a graphite pencil of the same grade are good for making small studies of roots or grass banks – choose whatever will suit your own style as well as the subject, and take the time to understand what each medium can do, and how you can best utilize it.

One point that recurs in this section is that you must take as much care over the trees that make up the mass of the woodland as the foreground ones that are your main concern.

Typical Problems

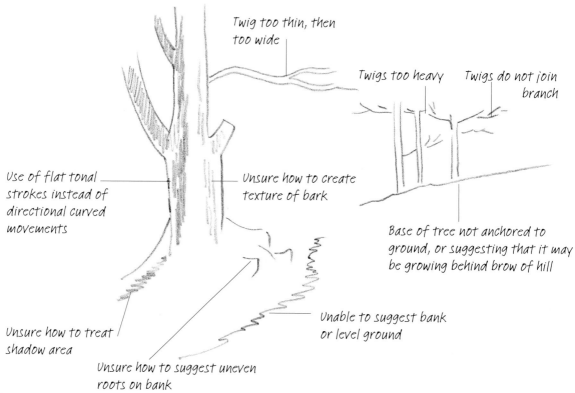

Twig too thin, then too wide

Twigs too heavy

Twigs do not join branch

Use of flat tonal strokes instead of directional curved movements

Unsure how to create texture of bark

Base of tree not anchored to ground, or suggesting that it may be growing behind brow of hill

Unsure how to treat shadow area

Unable to suggest bank or level ground

Unsure how to suggest uneven roots on bank

Solutions

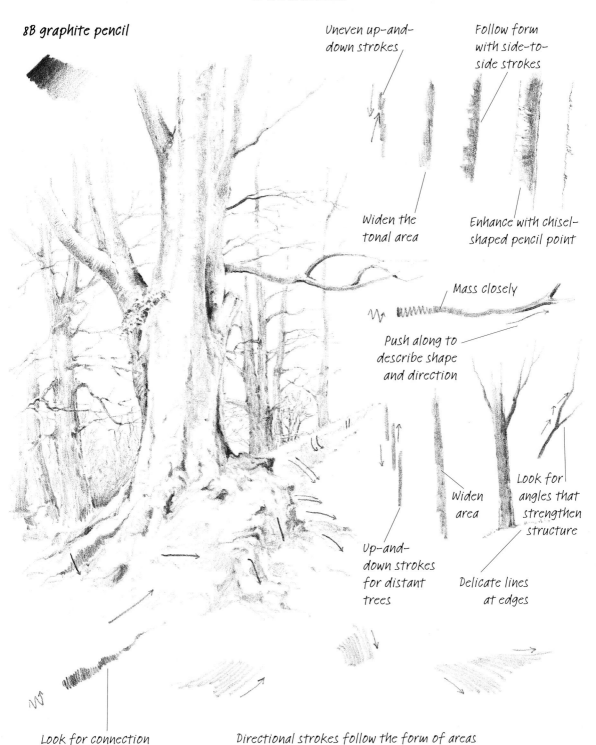

8B graphite pencil

Uneven up-and-down strokes

Follow form with side-to-side strokes

Widen the tonal area

Enhance with chisel-shaped pencil point

Mass closely

Push along to describe shape and direction

Widen area

Look for angles that strengthen structure

Up-and-down strokes for distant trees

Delicate lines at edges

Look for connection between shadow area and other directional tones

Directional strokes follow the form of areas toned to suggest shadow sides and curved banks

Typical Problems

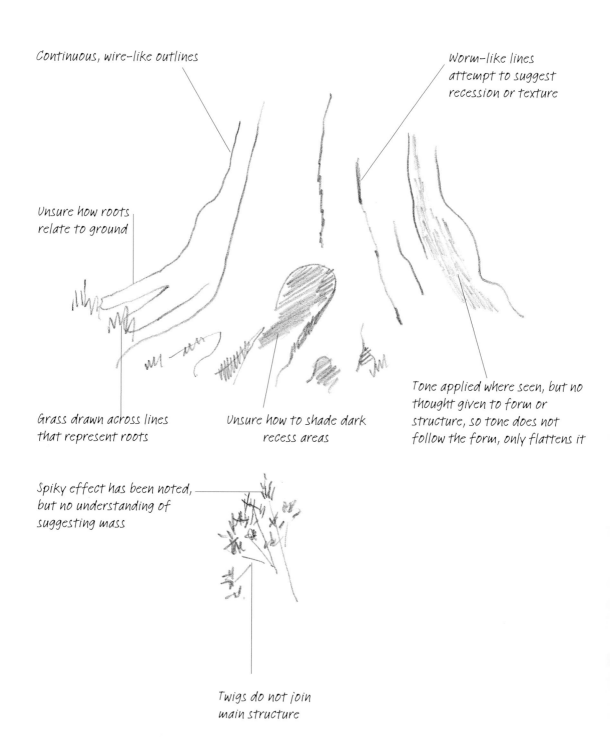

Continuous, wire-like outlines

Worm-like lines attempt to suggest recession or texture

Unsure how roots relate to ground

Grass drawn across lines that represent roots

Unsure how to shade dark recess areas

Tone applied where seen, but no thought given to form or structure, so tone does not follow the form, only flattens it

Spiky effect has been noted, but no understanding of suggesting mass

Twigs do not join main structure

Solutions

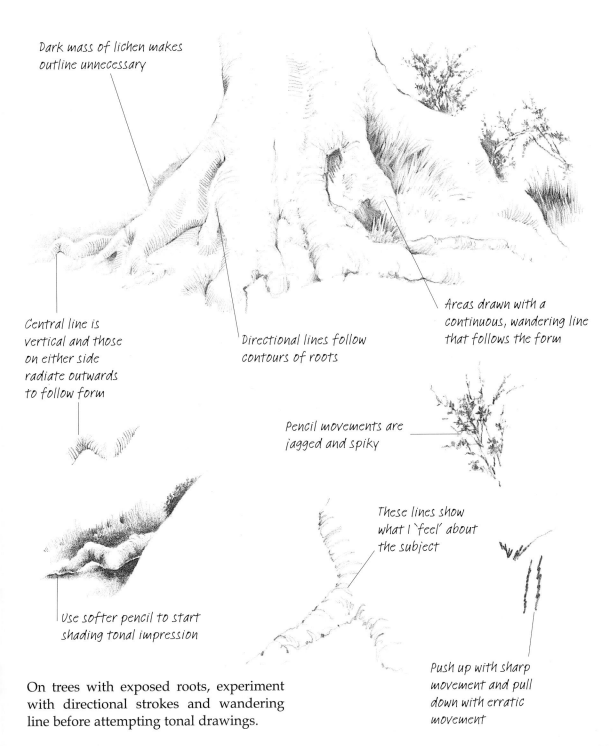

Dark mass of lichen makes outline unnecessary

Areas drawn with a continuous, wandering line that follows the form

Central line is vertical and those on either side radiate outwards to follow form

Directional lines follow contours of roots

Pencil movements are jagged and spiky

These lines show what I `feel` about the subject

Use softer pencil to start shading tonal impression

Push up with sharp movement and pull down with erratic movement

On trees with exposed roots, experiment with directional strokes and wandering line before attempting tonal drawings.

21

Typical Problems

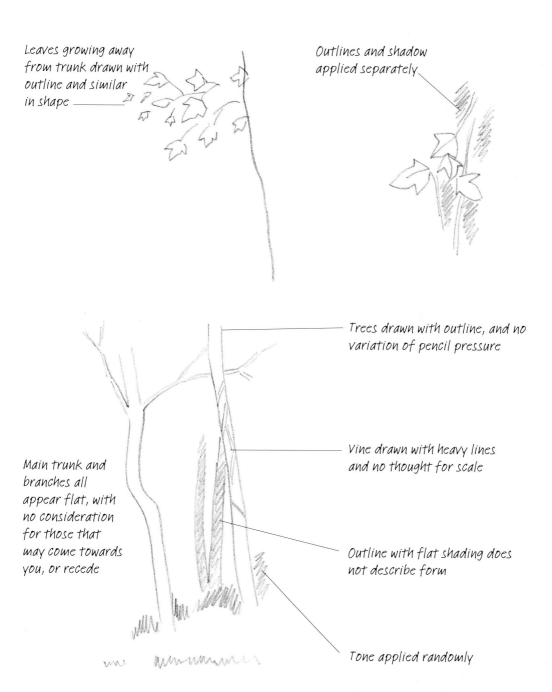

Leaves growing away from trunk drawn with outline and similar in shape

Outlines and shadow applied separately

Trees drawn with outline, and no variation of pencil pressure

Vine drawn with heavy lines and no thought for scale

Main trunk and branches all appear flat, with no consideration for those that may come towards you, or recede

Outline with flat shading does not describe form

Tone applied randomly

Solutions

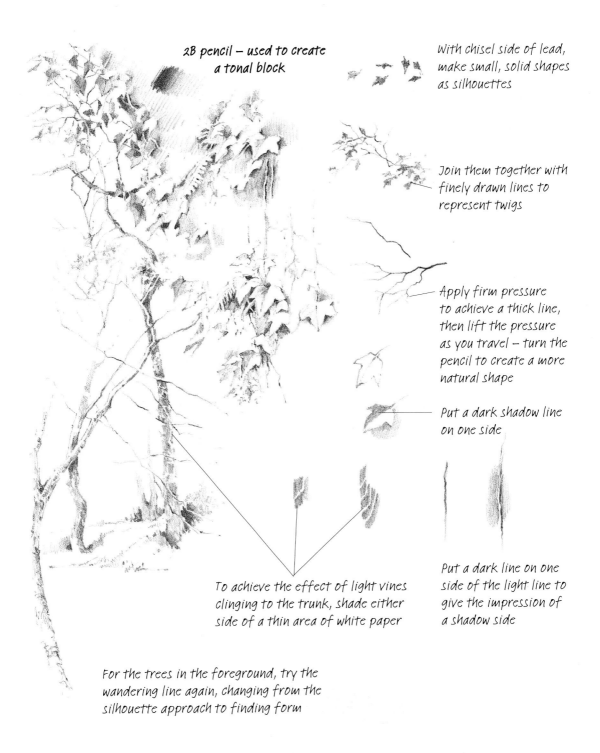

2B pencil – used to create
a tonal block

With chisel side of lead,
make small, solid shapes
as silhouettes

Join them together with
finely drawn lines to
represent twigs

Apply firm pressure
to achieve a thick line,
then lift the pressure
as you travel – turn the
pencil to create a more
natural shape

Put a dark shadow line
on one side

To achieve the effect of light vines
clinging to the trunk, shade either
side of a thin area of white paper

Put a dark line on one
side of the light line to
give the impression of
a shadow side

For the trees in the foreground, try the
wandering line again, changing from the
silhouette approach to finding form

Typical Problems

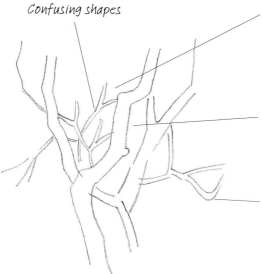

Confusing shapes

Branches drawn with no thought for the negative shape between them

Gaps left by accident, not design

Curve quickly drawn, without thought for structure

All lines drawn with same pressure on pencil

Smaller twigs are not growing from angles

This mass started with observation of ivy leaf shapes, but ended with shapes not resembling the leaf at all

These small squiggles representing leaves are drawn with no thought for how to show a mass by using the shapes between the leaves

Solutions

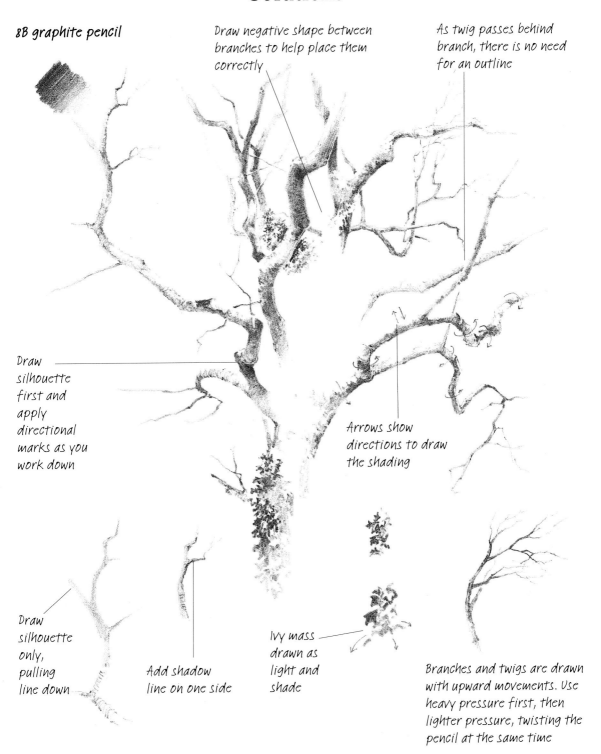

8B graphite pencil

Draw negative shape between branches to help place them correctly

As twig passes behind branch, there is no need for an outline

Draw silhouette first and apply directional marks as you work down

Arrows show directions to draw the shading

Draw silhouette only, pulling line down

Add shadow line on one side

Ivy mass drawn as light and shade

Branches and twigs are drawn with upward movements. Use heavy pressure first, then lighter pressure, twisting the pencil at the same time

Demonstration

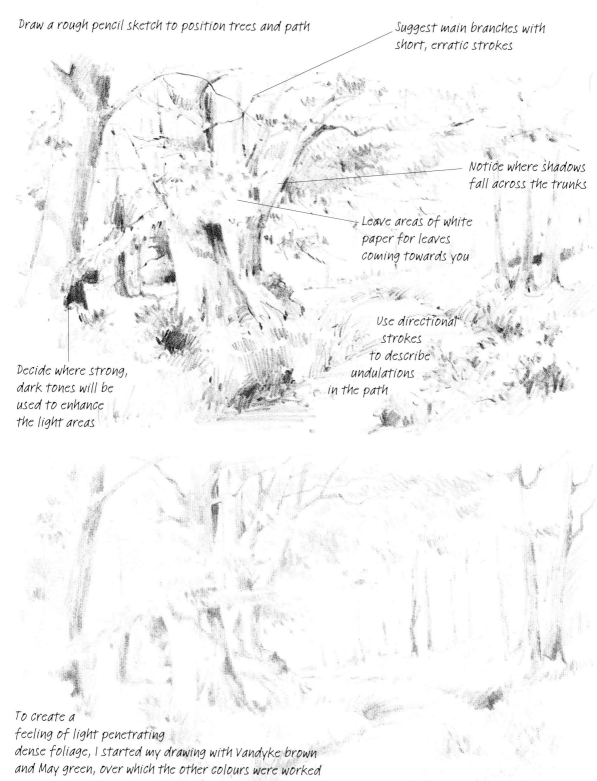

Draw a rough pencil sketch to position trees and path

Suggest main branches with short, erratic strokes

Notice where shadows fall across the trunks

Leave areas of white paper for leaves coming towards you

Use directional strokes to describe undulations in the path

Decide where strong, dark tones will be used to enhance the light areas

To create a feeling of light penetrating dense foliage, I started my drawing with Vandyke brown and May green, over which the other colours were worked

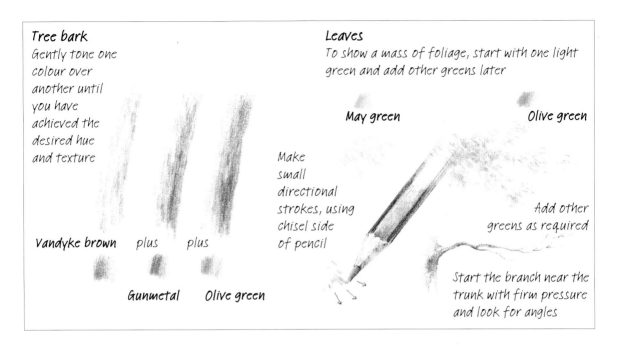

Tree bark
Gently tone one colour over another until you have achieved the desired hue and texture

Vandyke brown plus plus

Gunmetal **Olive green**

Leaves
To show a mass of foliage, start with one light green and add other greens later

May green **Olive green**

Make small directional strokes, using chisel side of pencil

Add other greens as required

Start the branch near the trunk with firm pressure and look for angles

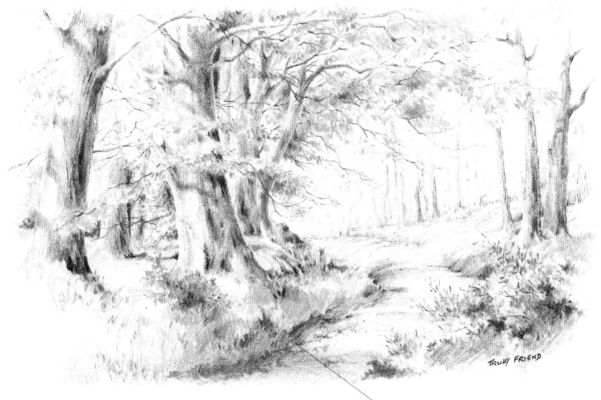

TRUDY FRIEND

It is important to decide where light paper will remain untouched. The build-up of colours is gradual, starting with gentle pressure on the pencil.

Cool Gunmetal is used within the shadow areas

Open Landscapes and Skies

In addition to looking at the open country-side, this theme emphasizes the importance of choosing the correct materials to suit the subject and techniques used.

A smooth white drawing paper provides an ideal surface when used with a hard-grade pencil, such as HB, to create controlled effects on clouds and sky. In contrast to this, use a soft pencil, such as 7B, to create textures using varied pressure; you can increase your options by also using a textured, rougher paper or card. This is ideal when using the chisel side of the lead (produced by rubbing to create the tonal mass).

In contrast to concentrating on the details and single bulk of trees, in this theme forests and woods are likely to be part of the middle or far distance. However, the principles for drawing them remain – use a variety of pencils to create leaf, bark and foliage mass effects with the directional strokes that are so important in drawing.

Typical Problems

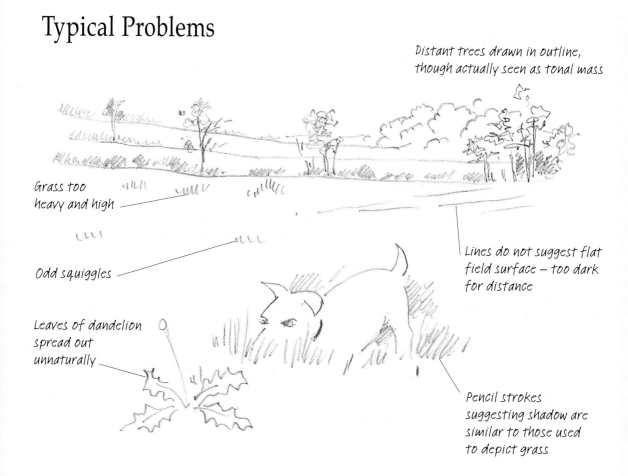

Distant trees drawn in outline, though actually seen as tonal mass

Grass too heavy and high

Odd squiggles

Leaves of dandelion spread out unnaturally

Lines do not suggest flat field surface – too dark for distance

Pencil strokes suggesting shadow are similar to those used to depict grass

Solutions

5B graphite pencil

1. For distant trees and bushes on a hill, draw basic constructive doodle lines using the chisel side of the pencil.

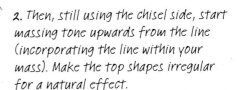

2. Then, still using the chisel side, start massing tone upwards from the line (incorporating the line within your mass). Make the top shapes irregular for a natural effect.

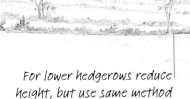

For lower hedgerows reduce height, but use same method

Vary pressure for different tonal effects within mass to suggest shadow areas

Make suggestions of grass in the distance smaller and paler, and those in the foreground larger and darker

Dandelion appears very large (because nearer to us) against terrier

Use shadow shapes to anchor subject

To achieve grass effect, place shapes as positives

Fill in negative spaces with dark tone

Typical Problems

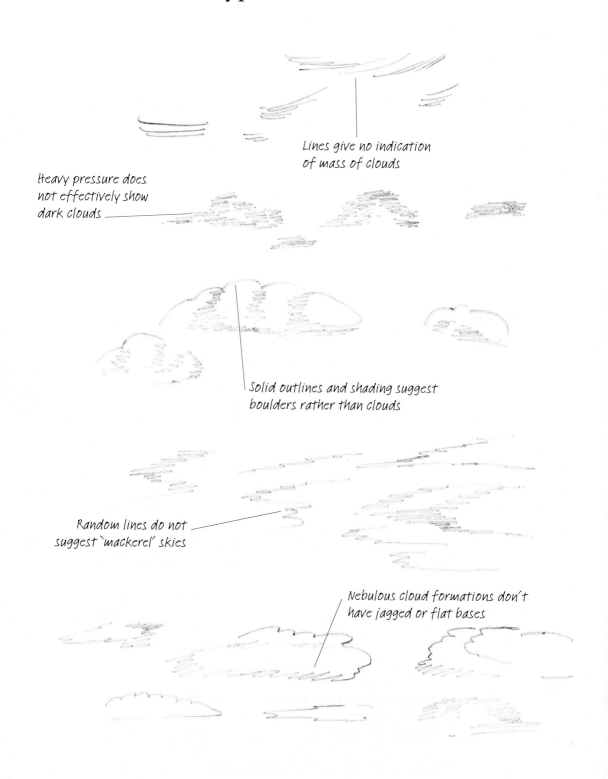

Lines give no indication
of mass of clouds

Heavy pressure does
not effectively show
dark clouds

Solid outlines and shading suggest
boulders rather than clouds

Random lines do not
suggest 'mackerel' skies

Nebulous cloud formations don't
have jagged or flat bases

Solutions

HB graphite pencil

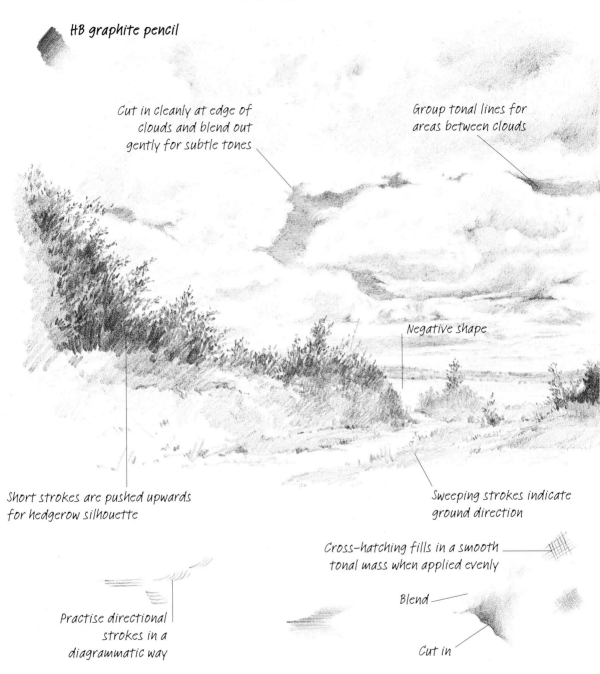

Cut in cleanly at edge of
clouds and blend out
gently for subtle tones

Group tonal lines for
areas between clouds

Negative shape

Short strokes are pushed upwards
for hedgerow silhouette

Sweeping strokes indicate
ground direction

Cross-hatching fills in a smooth
tonal mass when applied evenly

Practise directional
strokes in a
diagrammatic way

Blend

Cut in

I chose a sky with plenty of cloud to show
how recession and distance can be created at
the base by shading closer together. Take your
time – the tonal masses are built up, layer
upon layer, with even pencil pressure.

Typical Problems

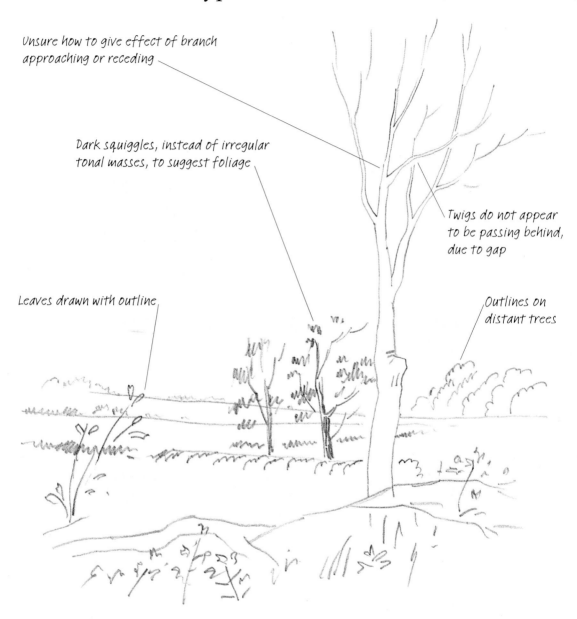

Unsure how to give effect of branch approaching or receding

Dark squiggles, instead of irregular tonal masses, to suggest foliage

Twigs do not appear to be passing behind, due to gap

Leaves drawn with outline

Outlines on distant trees

Many beginners experience problems with the use of tone, so tend, therefore, to depict everything with the use of an outline. I used a very soft pencil for the drawing on page 33, which shows how varied pressure can produce interesting textures on shapes. An outline is not necessary. Light, uneven lines may be used on sunlit surfaces and dark shadow lines will form a contrast as a tonal mass.

Solutions

7B graphic pencil

Be conscious not only of the shapes between objects and parts of objects, but also the shapes between the edge of the paper (or mount) and the object

Introduce short, directional strokes to create foliage mass

Let some areas pass off edge of paper

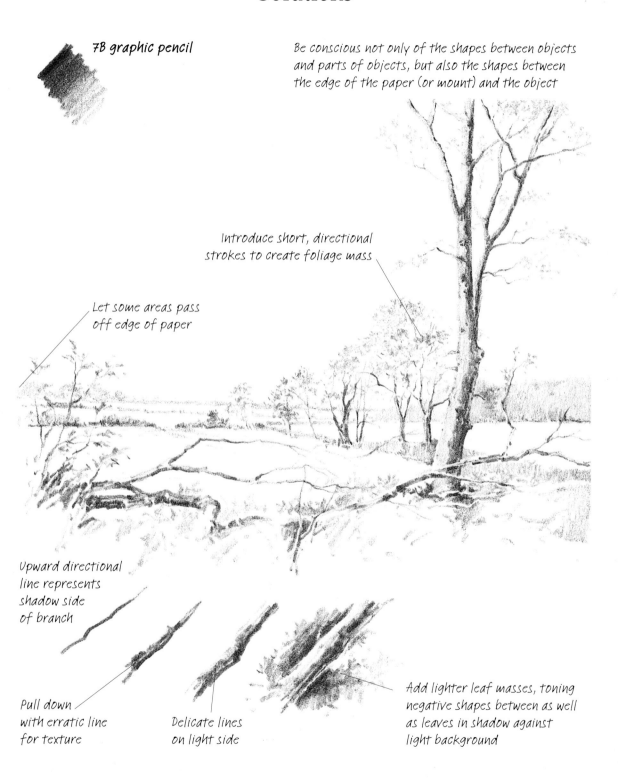

Upward directional line represents shadow side of branch

Pull down with erratic line for texture

Delicate lines on light side

Add lighter leaf masses, toning negative shapes between as well as leaves in shadow against light background

Typical Problems

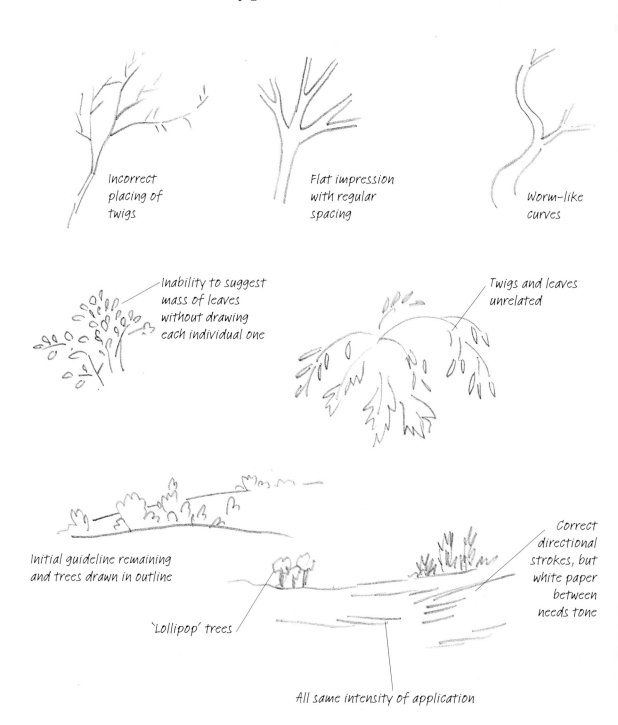

Incorrect placing of twigs

Flat impression with regular spacing

Worm-like curves

Inability to suggest mass of leaves without drawing each individual one

Twigs and leaves unrelated

Initial guideline remaining and trees drawn in outline

'Lollipop' trees

Correct directional strokes, but white paper between needs tone

All same intensity of application

Solutions

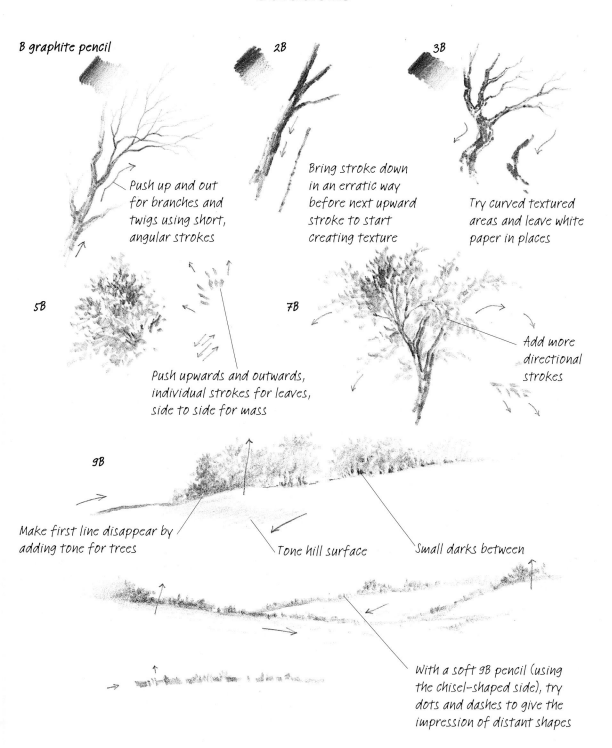

B graphite pencil

Push up and out for branches and twigs using short, angular strokes

2B

Bring stroke down in an erratic way before next upward stroke to start creating texture

3B

Try curved textured areas and leave white paper in places

5B

Push upwards and outwards, individual strokes for leaves, side to side for mass

7B

Add more directional strokes

9B

Make first line disappear by adding tone for trees

Tone hill surface

Small darks between

With a soft 9B pencil (using the chisel-shaped side), try dots and dashes to give the impression of distant shapes

Demonstration

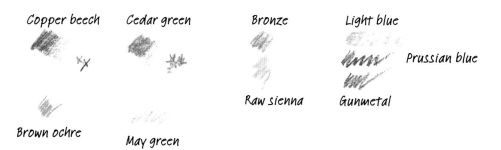

Copper beech Cedar green Bronze Light blue

Prussian blue

Raw sienna Gunmetal

Brown ochre May green

Here is an opportunity to use brushes and water alongside pencils, using pencil strokes in a similar way to brush techniques. As drawing and watercolour painting are so closely linked you will find water-soluble pencils the ideal medium for the transition between the two methods.

The choice of watercolour pencil hues for this view of open landscape with straw bales is shown above. Not only do the round bales provide contrasting shapes within the composition, but they also help to achieve the sense of strong perspective I felt was needed here.

Dry pencil on paper *Water added to this half of the study*

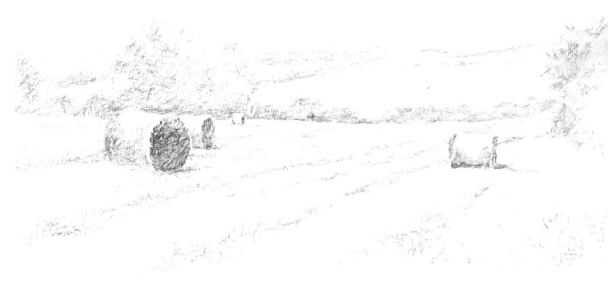

1. Draw the scene very lightly in Copper beech and Cedar green, paying attention to the feeling of recession.

2. Gently apply Bronze, Raw sienna and Brown ochre to the surface to achieve the textured masses.

The rough surface of watercolour paper helps the textured effect, and the 300 gsm (140 lb) paper allows easy blending when water is added.

The jagged edge of the bales is achieved by making a mass of crosses. When water is later added the colour changes

The effect of the tree masses is achieved in exactly the same way as with the graphic pencil exercises

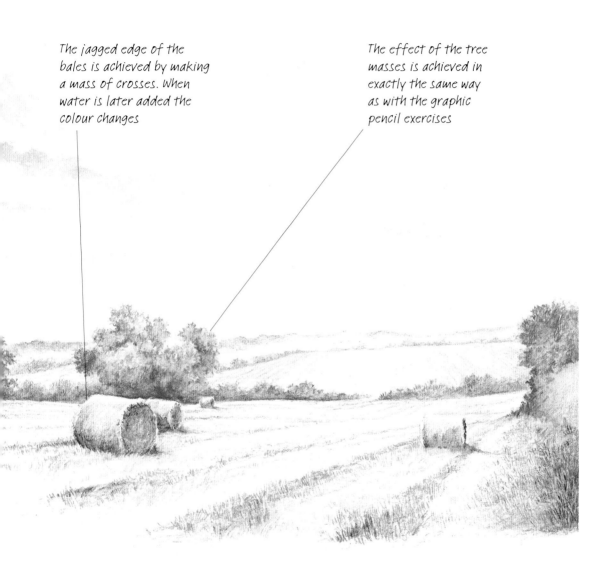

3. Gently brush clean water over the surface of the paper. This causes the pigments to dilute and produces slightly textured washes. When dry, apply detailed drawing over the washed areas, using directional pencil strokes to suggest growth of new grass amongst the stubble.

4. Add more layers of water to your work and, when dry, apply pencil drawing until you are satisfied that the desired effect has been achieved. All these pencil movements are the same as those used with ordinary graphic pencils.

Water in Landscapes

Water moves in response to how it is disturbed – it is only very rarely that you see a completely placid, still expanse – so each of the examples in this theme demonstrates how the surface of water is influenced by the factors and objects around it. Beginners may not wish to attempt to draw birds or bridges, but do practise the darks and lights of the ripples and notice the shapes between.

Another vital point to remember is that, with the exception of muddied waters, water takes its colour from reflections above or beside it, or from what is beneath and in it.

Because of this, it is worth paying attention to shadows created by reflected objects.

If a subject appears to be complicated, look at small areas at a time, perhaps using a viewfinder. Analyse what you see and think of it in a diagrammatic way in order to understand the shapes, notice how they are formed, and practise them.

It is also a good idea to take photographs of scenes that feature water; the demonstration and solutions in this section will be easier if you have references – but remember that there is no substitute for direct observation.

Typical Problems

Worm-like strokes

Up-and-down movements on side-to-side strokes that are unrelated to each other

Roughly scribbled tonal mass

Zigzags are the basis for some reflections and only require a little more understanding of the subject to be used successfully

Solutions

9B graphite pencil

This produces more texture on delicate areas than may be required, but is ideal for strong, sweeping strokes

Practice marks

It is a good idea to practise a variety of marks suggesting movement with varied pressure on the pencil, to see which effects you prefer

B graphite pencil

For less texture, where gradation is required

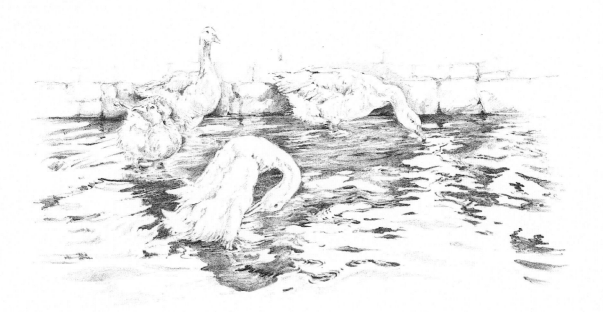

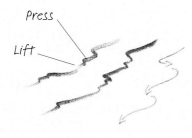

Press

Lift

Arrows show pencil movement

Using a 9B pencil on a pad of paper (which absorbs some of the pressure), you will achieve rich, dark sweeping strokes. Do not be afraid to press down really hard before lifting again. Look closely at some of the areas within the above study and try to achieve some of the undulations you can see here.

Typical Problems

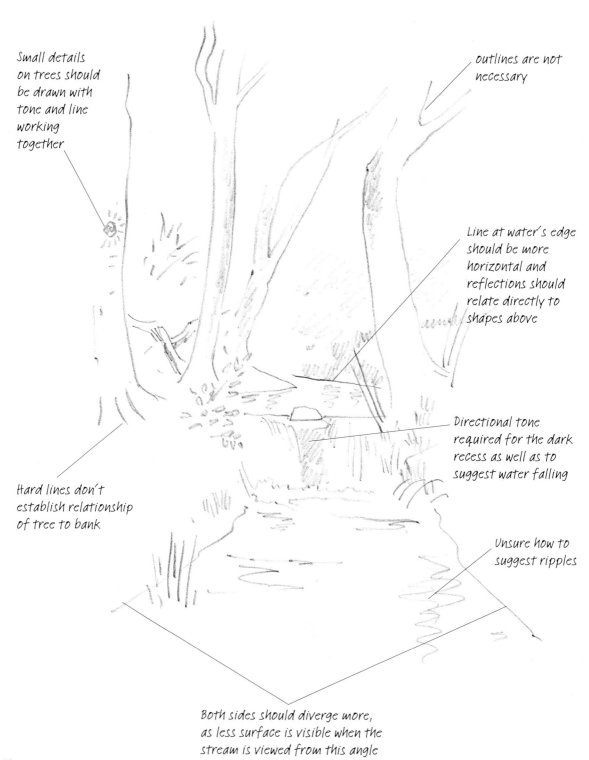

Small details on trees should be drawn with tone and line working together

outlines are not necessary

Line at water's edge should be more horizontal and reflections should relate directly to shapes above

Hard lines don't establish relationship of tree to bank

Directional tone required for the dark recess as well as to suggest water falling

Unsure how to suggest ripples

Both sides should diverge more, as less surface is visible when the stream is viewed from this angle

Solutions

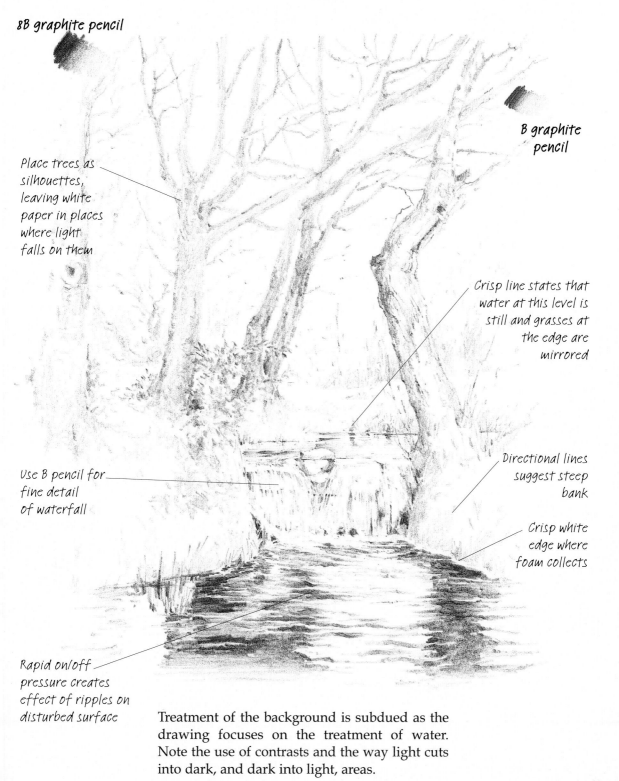

8B graphite pencil

Place trees as silhouettes, leaving white paper in places where light falls on them

B graphite pencil

Crisp line states that water at this level is still and grasses at the edge are mirrored

Use B pencil for fine detail of waterfall

Directional lines suggest steep bank

Crisp white edge where foam collects

Rapid on/off pressure creates effect of ripples on disturbed surface

Treatment of the background is subdued as the drawing focuses on the treatment of water. Note the use of contrasts and the way light cuts into dark, and dark into light, areas.

Typical Problems

A subject like this requires the use of tonal areas to give impact, and beginners often experience problems with tone when trying to show movement. I would advise close observation of water surfaces from life and from photographs.

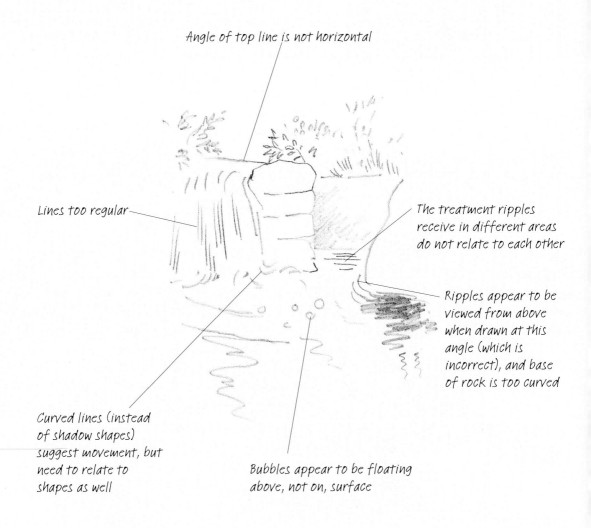

Angle of top line is not horizontal

Lines too regular

The treatment ripples receive in different areas do not relate to each other

Ripples appear to be viewed from above when drawn at this angle (which is incorrect), and base of rock is too curved

Curved lines (instead of shadow shapes) suggest movement, but need to relate to shapes as well

Bubbles appear to be floating above, not on, surface

Solutions

Often when we view a scene we see reflections and/or shadows within the area to be drawn that do not relate to what we see around them, but to something that is beyond and out of the picture. So, in this drawing I have added dark reflections in the foreground water that relate to trees above the small area that is depicted.

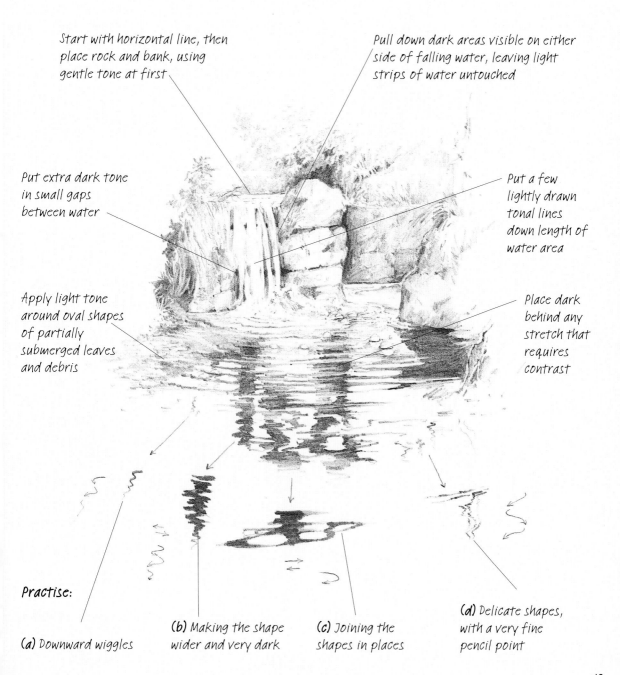

Start with horizontal line, then place rock and bank, using gentle tone at first

Pull down dark areas visible on either side of falling water, leaving light strips of water untouched

Put extra dark tone in small gaps between water

Put a few lightly drawn tonal lines down length of water area

Apply light tone around oval shapes of partially submerged leaves and debris

Place dark behind any stretch that requires contrast

Practise:

(a) Downward wiggles

(b) Making the shape wider and very dark

(c) Joining the shapes in places

(d) Delicate shapes, with a very fine pencil point

43

Typical Problems

Stones drawn in outline
give flat pattern

Identical lines along top of
bridge do not suggest
uneven stonework

Trees appear
to be floating
above bridge

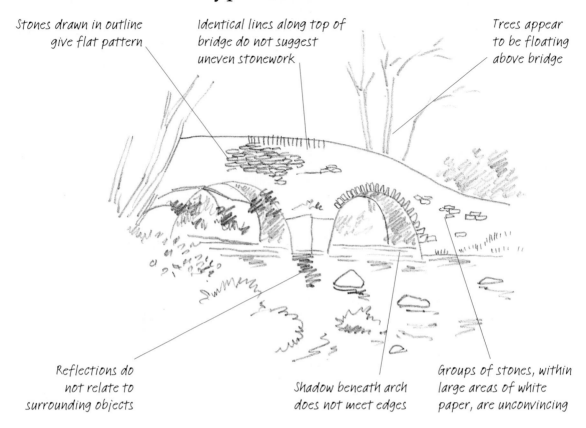

Reflections do
not relate to
surrounding objects

Shadow beneath arch
does not meet edges

Groups of stones, within
large areas of white
paper, are unconvincing

Too much of puddle's
surface at this angle to
be accurate

Very muddled
treatment near tree

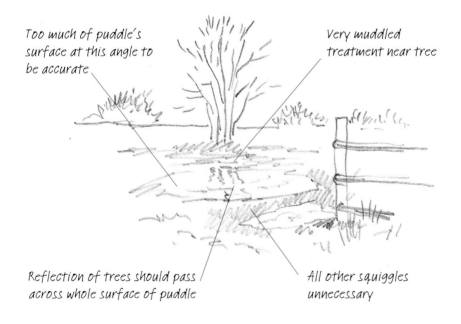

Reflection of trees should pass
across whole surface of puddle

All other squiggles
unnecessary

Solutions

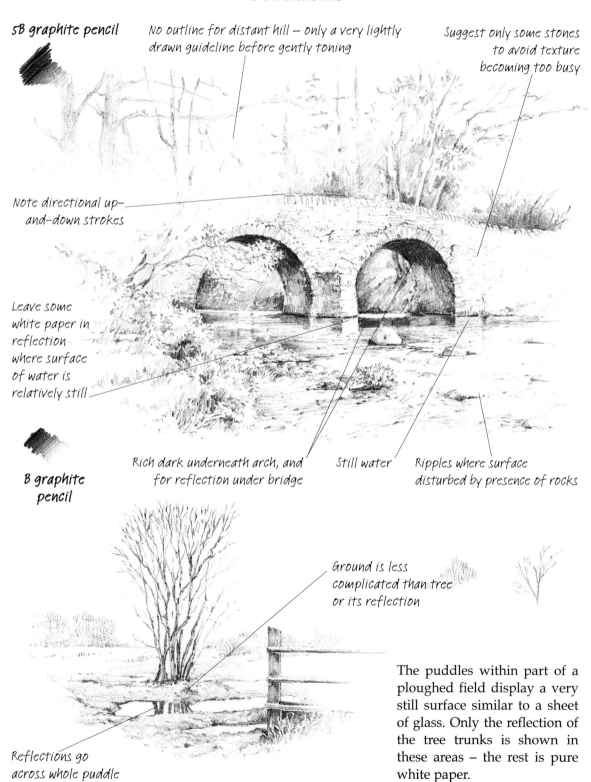

5B graphite pencil

No outline for distant hill – only a very lightly drawn guideline before gently toning

Suggest only some stones to avoid texture becoming too busy

Note directional up-and-down strokes

Leave some white paper in reflection where surface of water is relatively still

B graphite pencil

Rich dark underneath arch, and for reflection under bridge

Still water

Ripples where surface disturbed by presence of rocks

Ground is less complicated than tree or its reflection

The puddles within part of a ploughed field display a very still surface similar to a sheet of glass. Only the reflection of the tree trunks is shown in these areas – the rest is pure white paper.

Reflections go across whole puddle

Demonstration

B graphic pencil

Twist pencil as you travel to achieve delicate twig effects, lifting gently off while twisting

Irregular pressure, downward line

Repeat and work on this (with varied pressure) to achieve effect of bark

Treat bank with directional strokes before adding grass

Tick and flick for grass. The same in pastel as pencil

Keep water reflections horizontal

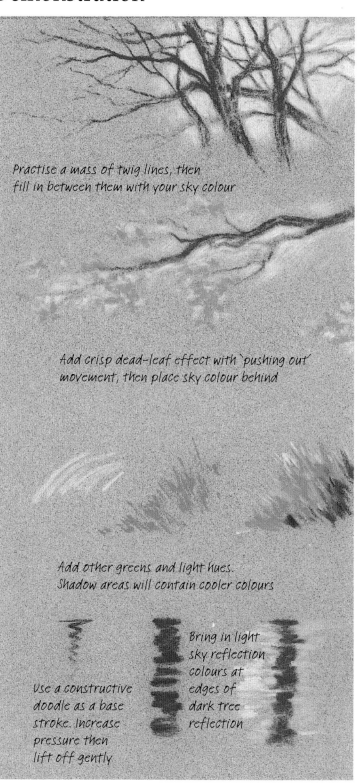

Practise a mass of twig lines, then fill in between them with your sky colour

Add crisp dead-leaf effect with `pushing out` movement, then place sky colour behind

Add other greens and light hues. Shadow areas will contain cooler colours

Use a constructive doodle as a base stroke. Increase pressure then lift off gently

Bring in light sky reflection colours at edges of dark tree reflection

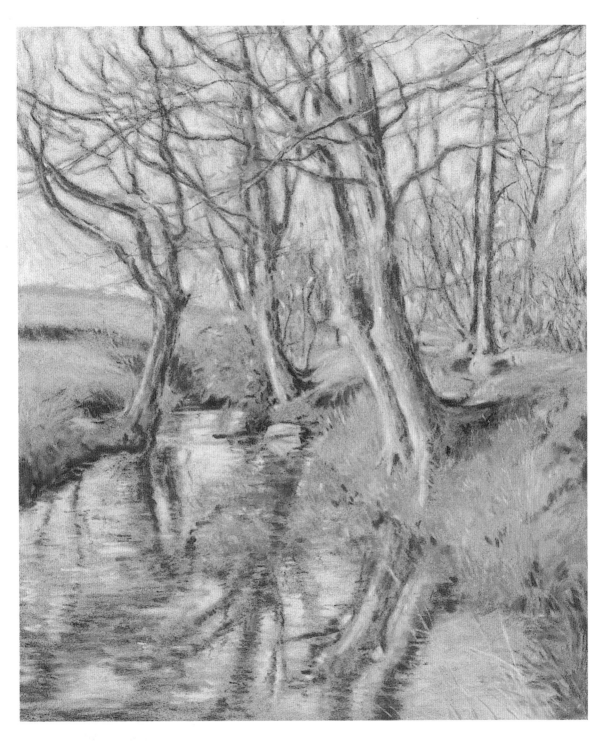

This is worked in pastel pencils on pastel board, and the softness of the medium suits the tranquil subject. The treatment is identical to the pencil methods. A coloured ground makes full use of the white and lighter pastel pencil colours.

Buildings in Landscapes

Barns and houses in the countryside – whether they are in good condition and occupied or derelict and crumbling – offer a wealth of subject matter for the artist, and can be found in countries all over the world.

The combination of natural landscape and man-made architecture is an appealing one, and provides you with many choices. Do you want to view the building from afar as part of the countryside, get in close to frame it as your focal point, or even concentrate on details that are unique to it? This is when carrying a viewfinder can come in very useful – take time to look at the buildings from as many angles as possible until you are satisfied that the viewpoint you have chosen is interesting and achievable.

Another point to note is that, unlike the situation in villages, town and cities, where buildings can crowd upwards as well as sideways, the sky plays as much of a part as the ground around the building. Look at the previous themes, and bring what you have learned from them to this theme.

Typical Problems

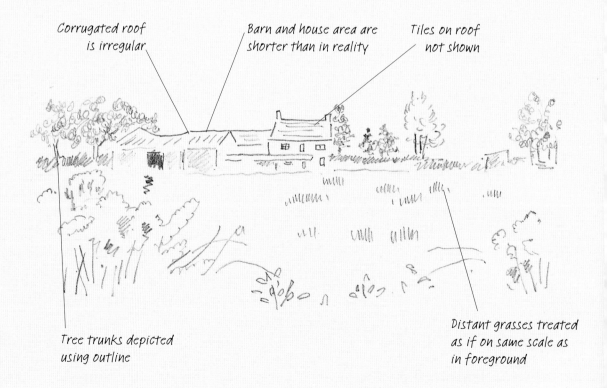

Corrugated roof is irregular

Barn and house area are shorter than in reality

Tiles on roof not shown

Tree trunks depicted using outline

Distant grasses treated as if on same scale as in foreground

Solutions

B graphite pencil

Keep sky simple with light, sweeping strokes of chisel side of lead

Trunk and branches are silhouettes at this distance with gaps for foliage

Note important shadow shapes on adjoining surfaces

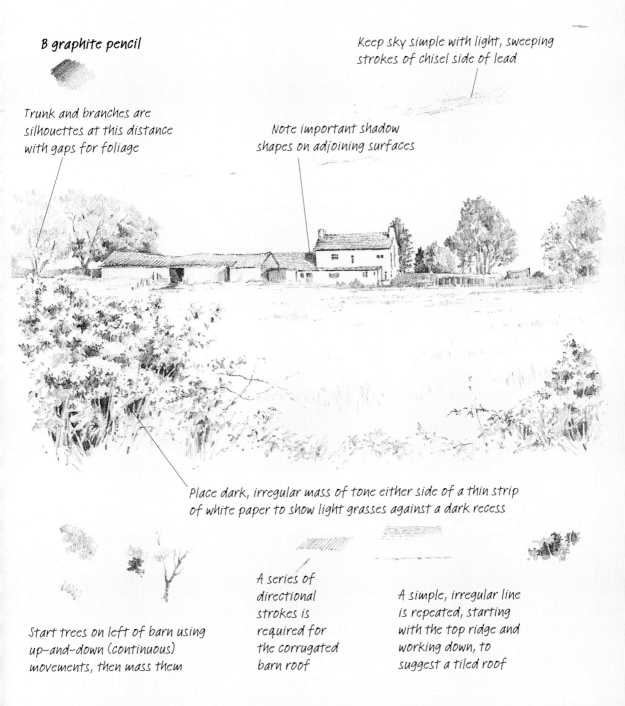

Place dark, irregular mass of tone either side of a thin strip of white paper to show light grasses against a dark recess

Start trees on left of barn using up-and-down (continuous) movements, then mass them

A series of directional strokes is required for the corrugated barn roof

A simple, irregular line is repeated, starting with the top ridge and working down, to suggest a tiled roof

Note how the slender grasses in the field are not drawn in detail until they are in the foreground. For distant grasses, light, side-to-side strokes (made with an up-and-down movement) suggest shadows across the surface of the field.

Typical Problems

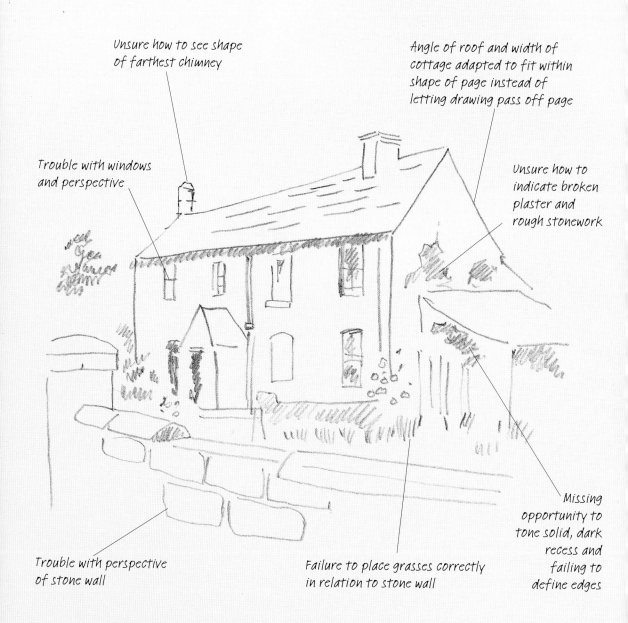

Unsure how to see shape
of farthest chimney

Angle of roof and width of
cottage adapted to fit within
shape of page instead of
letting drawing pass off page

Trouble with windows
and perspective

Unsure how to
indicate broken
plaster and
rough stonework

Trouble with perspective
of stone wall

Failure to place grasses correctly
in relation to stone wall

Missing
opportunity to
tone solid, dark
recess and
failing to
define edges

The problems here have arisen because the
house is drawn in the form of an outline rather
than working from within and relating positions
of windows, porch, chimneys and so on. Using
guidelines and shapes between would help.

Solutions

3B graphite pencil

A 3B pencil achieves rich, dark areas of tone, while still enabling a fine line to be drawn after a chisel shape is used

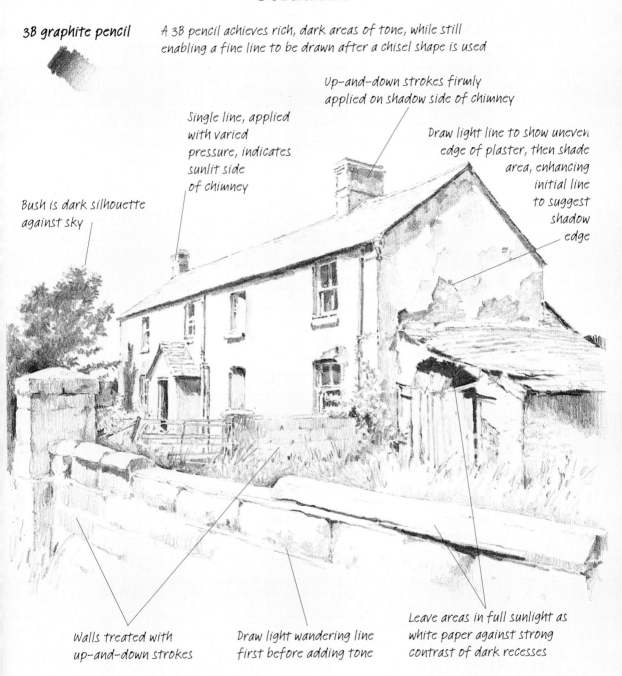

Up-and-down strokes firmly applied on shadow side of chimney

Single line, applied with varied pressure, indicates sunlit side of chimney

Draw light line to show uneven edge of plaster, then shade area, enhancing initial line to suggest shadow edge

Bush is dark silhouette against sky

Walls treated with up-and-down strokes

Draw light wandering line first before adding tone

Leave areas in full sunlight as white paper against strong contrast of dark recesses

Driving through the countryside you may be lucky enough to discover a derelict farmhouse with outbuildings that is an absolute gift to the artist. On the day I came across this building it was in bright sunlight, affording me the opportunity to use dark and light contrasts to full effect, and also many different textured surfaces.

51

Typical Problems

Close observation, perhaps with the aid of a few detailed studies, is advisable before starting the main drawing.

Difficulty in indicating the steep slope of tiled roof above eye level

Treatment of stonework surface shows lack of understanding of perspective

Opportunity for capturing dark, negative shapes, created by position of the open gate, has not been used to advantage

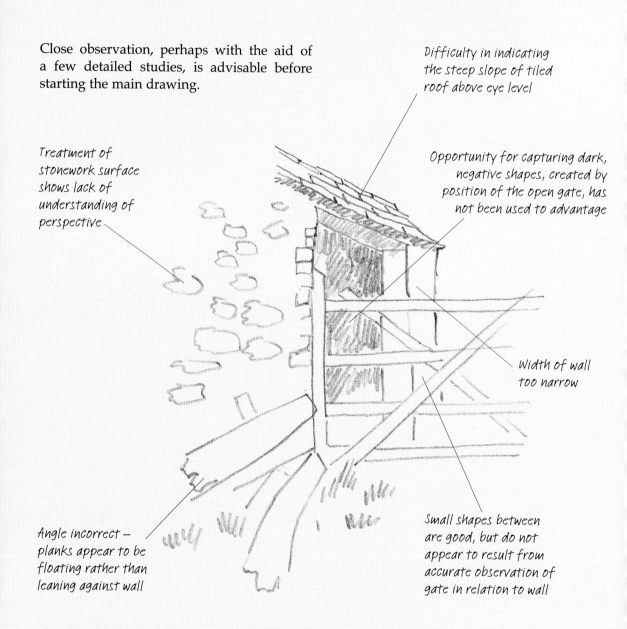

Width of wall too narrow

Angle incorrect – planks appear to be floating rather than leaning against wall

Small shapes between are good, but do not appear to result from accurate observation of gate in relation to wall

A drawing from an unusual angle can encourage the beginner to concentrate more on the shapes between than the actual outline of the forms. Learning to forget what the subject actually is, while placing elements accurately with the aid of guidelines, is a great advantage.

Solutions

3B graphite pencil

Draw only a few (on/off pressure) lines in correct direction to suggest tiled area

Start dark tone under eaves with up-and-down movements to form mass of shadow

Shade under here in direction of arrow

Cement between bricks is shaded in medium tone

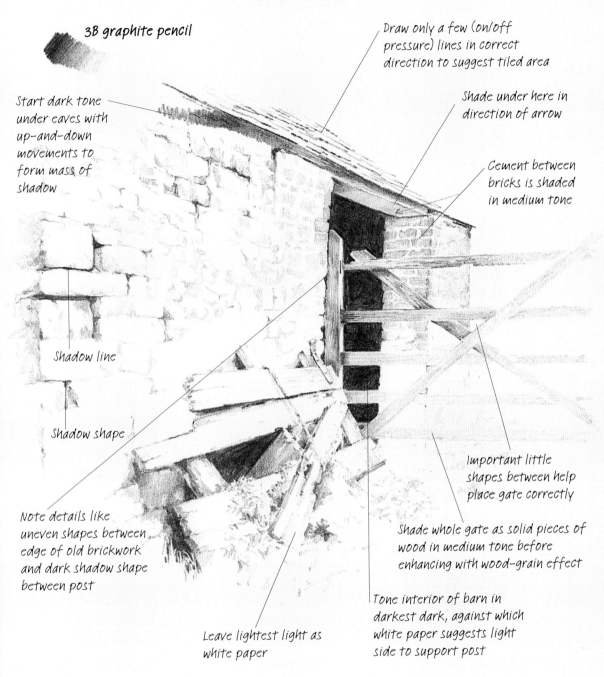

Shadow line

Shadow shape

Important little shapes between help place gate correctly

Note details like uneven shapes between edge of old brickwork and dark shadow shape between post

Shade whole gate as solid pieces of wood in medium tone before enhancing with wood-grain effect

Leave lightest light as white paper

Tone interior of barn in darkest dark, against which white paper suggests light side to support post

Practise your scales:

Tone the darkest dark as dense as possible

Just as a musician requires notes in order to play a tune, you need your tones to create a drawing. Try to use a variety of tones.

Typical Problems

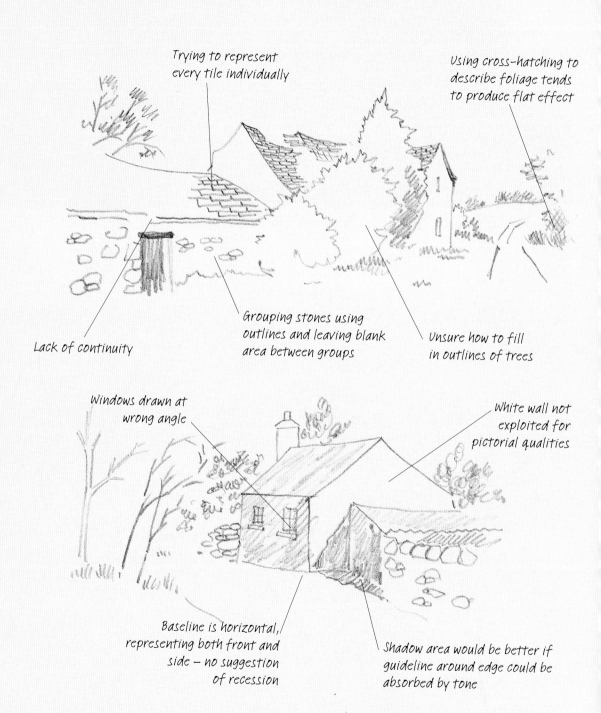

Trying to represent every tile individually

Using cross-hatching to describe foliage tends to produce flat effect

Lack of continuity

Grouping stones using outlines and leaving blank area between groups

Unsure how to fill in outlines of trees

Windows drawn at wrong angle

White wall not exploited for pictorial qualities

Baseline is horizontal, representing both front and side – no suggestion of recession

Shadow area would be better if guideline around edge could be absorbed by tone

However detailed and carefully drawn an area may be, if the perspective is wrong, the drawing will not work.

Solutions

These two studies show how much white paper may be left untouched by the pencil when depicting trees, walls of buildings, sky and ground.

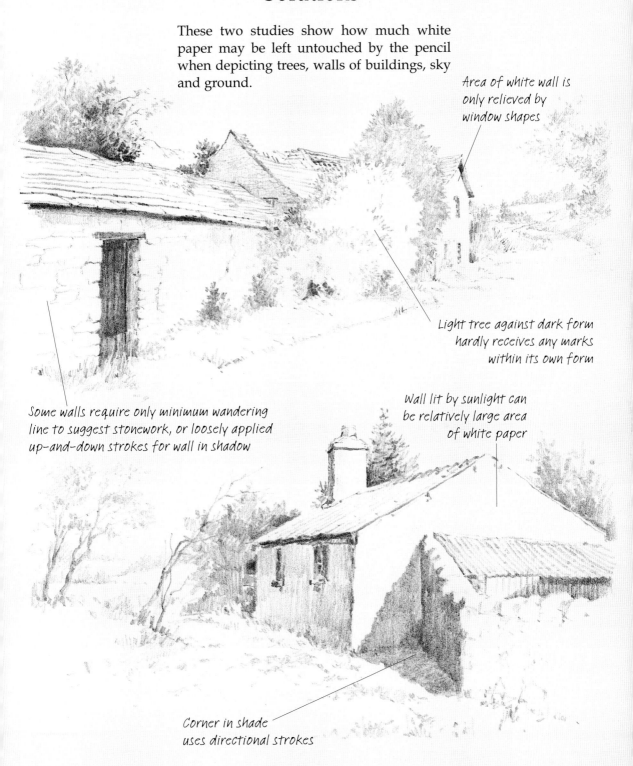

Area of white wall is only relieved by window shapes

Light tree against dark form hardly receives any marks within its own form

Some walls require only minimum wandering line to suggest stonework, or loosely applied up-and-down strokes for wall in shadow

Wall lit by sunlight can be relatively large area of white paper

Corner in shade uses directional strokes

Demonstration

This demonstration is worked with a coloured Derwent drawing pencil with a soft, creamy texture that provides a velvety finish. The extra-thick strip requires sharpening to a fine point for the delicate linear work on twigs and branches, but for most of this drawing the chisel side and point are used alternately.

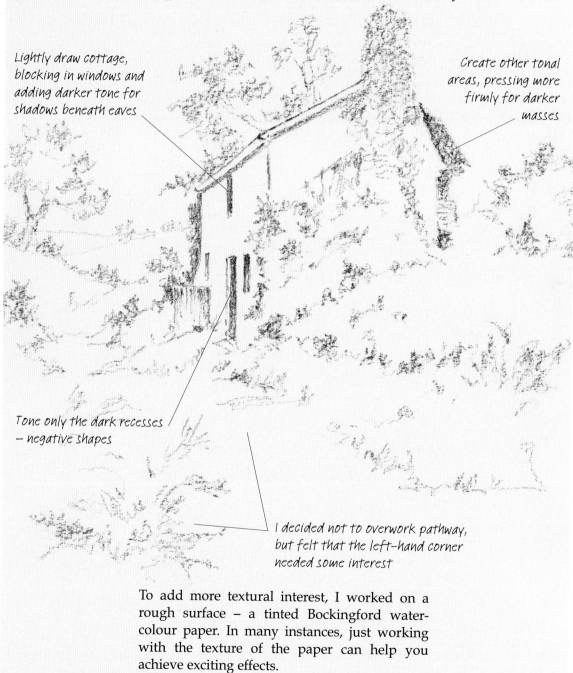

Lightly draw cottage, blocking in windows and adding darker tone for shadows beneath eaves

Create other tonal areas, pressing more firmly for darker masses

Tone only the dark recesses – negative shapes

I decided not to overwork pathway, but felt that the left-hand corner needed some interest

To add more textural interest, I worked on a rough surface – a tinted Bockingford watercolour paper. In many instances, just working with the texture of the paper can help you achieve exciting effects.

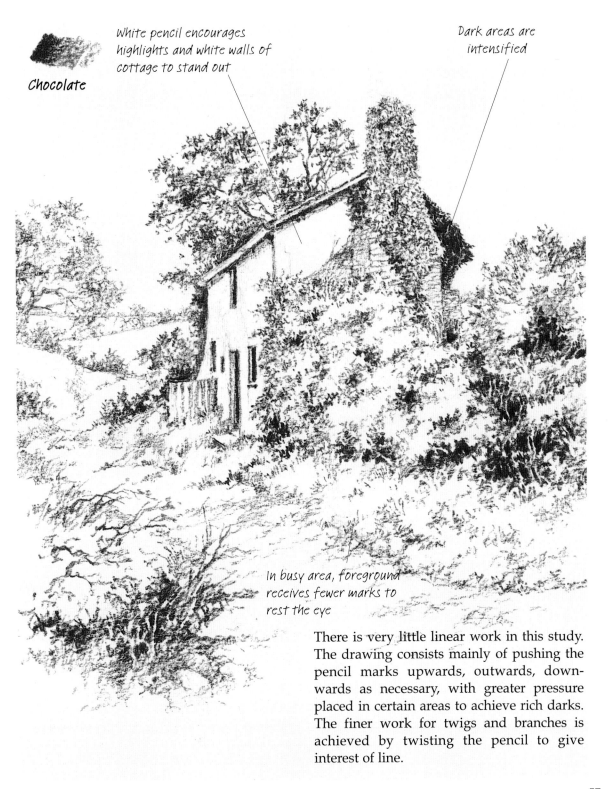

Chocolate

White pencil encourages highlights and white walls of cottage to stand out

Dark areas are intensified

In busy area, foreground receives fewer marks to rest the eye

There is very little linear work in this study. The drawing consists mainly of pushing the pencil marks upwards, outwards, downwards as necessary, with greater pressure placed in certain areas to achieve rich darks. The finer work for twigs and branches is achieved by twisting the pencil to give interest of line.

Village Houses and Cottages

Once you leave behind solitary buildings in the countryside and start looking for subjects in villages and small towns, your concerns may begin to change a little.

In addition to more perspective angles being necessary – especially in old streets with houses built in different eras – you may have to make some decisions about what to include in your drawing from the scene in front of you, and what to leave out.

This theme looks closely at perspective and reinforces the value of guidelines and shapes. Emphasis is also placed throughout on the importance of learning to observe closely the subject you choose to draw, noticing tiny details that are of great help within your work – such as the textures of thatched roof, stone walls, uneven tiles, grass and foliage. If you are lucky enough to find cobbled streets and flagstoned paths, these make excellent studies in their own right.

With this in mind, the studies of the buildings in this theme have been broken down in places to details in order to encourage close observation and the development of understanding and personal drawing skills. I hope this approach will help you understand the basic theory and allow you to use a more 'free' style confidently, if you wish, once it has become established.

Typical Problems

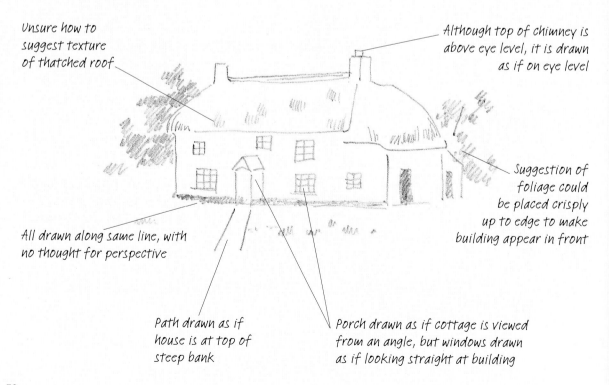

Unsure how to suggest texture of thatched roof

Although top of chimney is above eye level, it is drawn as if on eye level

Suggestion of foliage could be placed crisply up to edge to make building appear in front

All drawn along same line, with no thought for perspective

Path drawn as if house is at top of steep bank

Porch drawn as if cottage is viewed from an angle, but windows drawn as if looking straight at building

Solutions

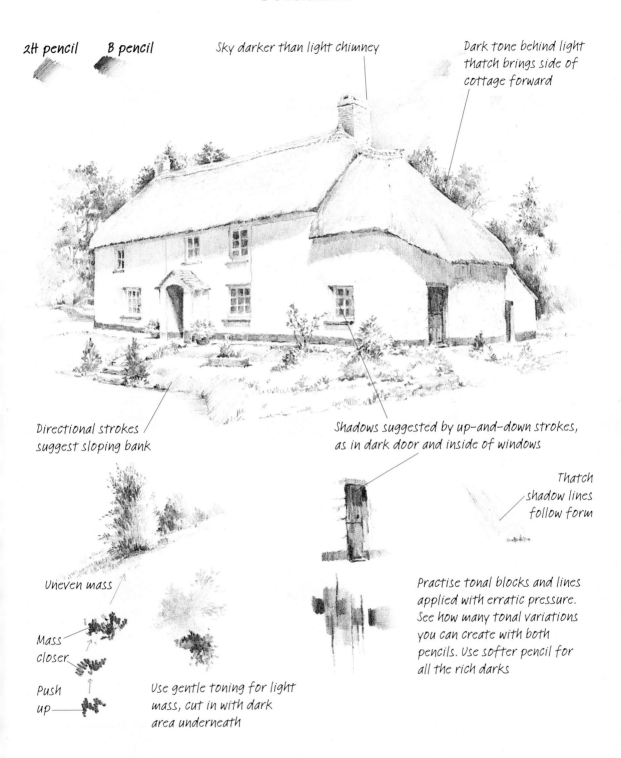

2H pencil

B pencil

Sky darker than light chimney

Dark tone behind light thatch brings side of cottage forward

Directional strokes suggest sloping bank

Shadows suggested by up-and-down strokes, as in dark door and inside of windows

Thatch shadow lines follow form

Uneven mass

Mass closer

Push up

Use gentle toning for light mass, cut in with dark area underneath

Practise tonal blocks and lines applied with erratic pressure. See how many tonal variations you can create with both pencils. Use softer pencil for all the rich darks

Typical Problems

These careless drawings can be easily corrected with closer observation. Allow yourself 'thinking time' before starting to draw, so that you can observe closely how elements fit together in relationship to one another.

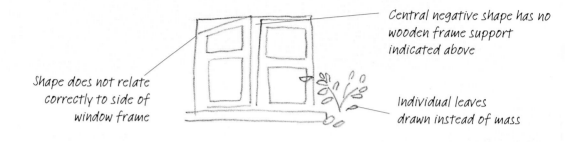

Central negative shape has no wooden frame support indicated above

Shape does not relate correctly to side of window frame

Individual leaves drawn instead of mass

Each tile drawn separately, with no thought for light or perspective

Stonework of wall too spaced out, with no consideration for relationships between stones

Stones placed as the scales of a fish, usually when you travel too quickly, placing one stone after another without thinking

Grasses placed one after the other, either massed or individually, with no regard for tonal values

Curved sides followed by straight sides, and all stones drawn with even pressure, producing wire-like outlines

Solutions

8B pencil

(large tonal areas)

B pencil

(fine lines)

Suggest timber framework with on/off pressure on up-and-down stroke

Change direction to a side-to-side (on/off) stroke for stonework

Arrows give idea which way to push or pull directional tonal strokes

When creating the impression of grass, 'think' your way into the movement

Start with a tick

Mass the ticks

Vary pressure so they are no longer recognizable as ticks

Note shadows

Start the open window by using the most important shapes

Draw around panes of glass

Fill in dark tone, leaving light bars

The on/off pressure used for depicting stones is similar to that for roof tiles over the porch. Lift pressure completely off the paper at times to suggest strong light, causing shadows between tiles to almost disappear

Typical Problems

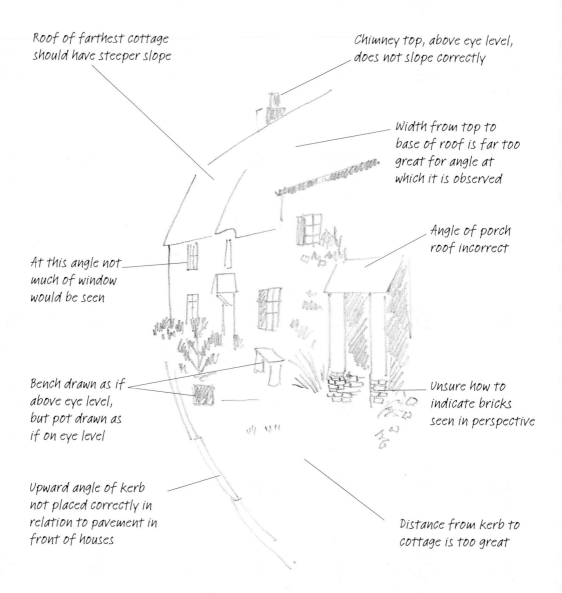

Roof of farthest cottage should have steeper slope

Chimney top, above eye level, does not slope correctly

Width from top to base of roof is far too great for angle at which it is observed

Angle of porch roof incorrect

At this angle not much of window would be seen

Bench drawn as if above eye level, but pot drawn as if on eye level

Unsure how to indicate bricks seen in perspective

Upward angle of kerb not placed correctly in relation to pavement in front of houses

Distance from kerb to cottage is too great

This is a difficult viewpoint for beginners to draw unless each part of the buildings is seen in relation to the next and observed as a shape (with the aid of vertical and horizontal guidelines). If you are using a photograph as reference, hold a straight edge against each part of the subject to check its dimensions. When drawing from life, hold a pencil in front of you, vertically or horizontally, relating this to the angles.

Solutions

HB pencil 2H graphic
pencil

Start the initial drawing with a 2H pencil,
both for the tonal masses and linear work

Shading applied
with vertical
strokes

Draw extent
of cast
shadow lightly first,
with downward
strokes shaded up
to, and including,
guideline

Use HB pencil for
darker areas and
shadow lines
between tiles
with on/off
pressure applied
to a continuous
stroke

Eye level

Draw a horizontal line
on eye level. Radiate
lines from it to help
place chimneys,
windows, porches and
the acute slope of the
thatched roofs

Delicate line drawn
with very sharp 2H
pencil adds crispness
to edge and
emphasizes contrast

Draw bricks as toned
blocks over toned area

Start the mass of leaves and
flowers as a light tone,
emphasizing shadow areas.
Subsequent applications of
tone will add depth. Areas of
white paper will represent white
flowers or light on leaves

A village street demonstrates simple
perspective as the cottages are built on a hill,
which offers interesting shapes. You may find
a detailed drawing like this rather daunting
at first. Do not try to copy it – just observe
and practise the individual aspects.

Typical Problems

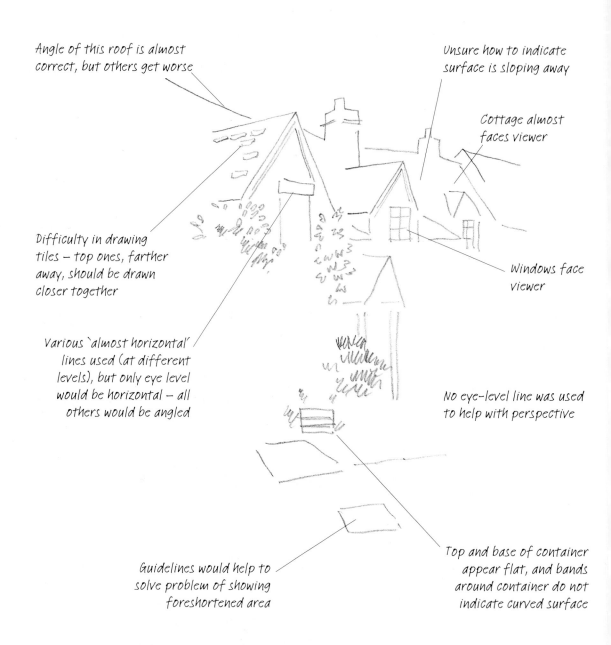

Angle of this roof is almost correct, but others get worse

Unsure how to indicate surface is sloping away

Cottage almost faces viewer

Difficulty in drawing tiles – top ones, farther away, should be drawn closer together

Windows face viewer

Various `almost horizontal' lines used (at different levels), but only eye level would be horizontal – all others would be angled

No eye-level line was used to help with perspective

Guidelines would help to solve problem of showing foreshortened area

Top and base of container appear flat, and bands around container do not indicate curved surface

With old cottages, much of the wall area may be covered in ivy or other creepers. Use the Trees and Woodland and Gardens themes to help you understand how to draw these surfaces.

Solutions

Noting similar shapes either side of the guideline, I put a small piece of tracing paper over the right-hand shape and turned the paper to place it over the shape on the left. By coincidence, they are identical

Negative area between chimneys is shaded

A visual contact point is where two forms are seen to cross.
Run guidelines from such points to place other parts of structure or objects some distance away

Ridge from dormer window crosses in front of other building's roof

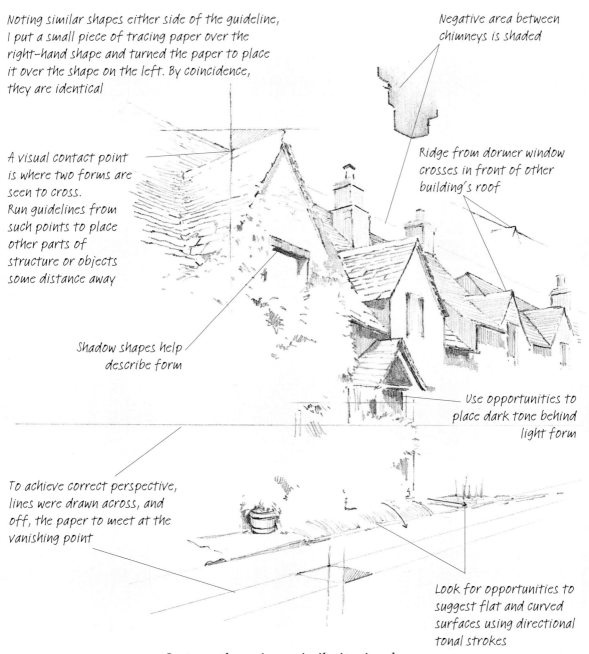

Shadow shapes help describe form

Use opportunities to place dark tone behind light form

To achieve correct perspective, lines were drawn across, and off, the paper to meet at the vanishing point

Look for opportunities to suggest flat and curved surfaces using directional tonal strokes

Just as there is a similarity in shape between the guidelines and the edge of the roof, the central area here is separated by two guidelines. Look also at the two smaller shapes between relating to the guidelines in the centre area.

Demonstration

This demonstration shows the importance of guidelines to place a structure correctly. From these, look for shapes between to help achieve correct angles.

The areas blocked in red are some of the small shapes that are not negative but are between a guideline and part of an object. Get these right, and the rest will follow.

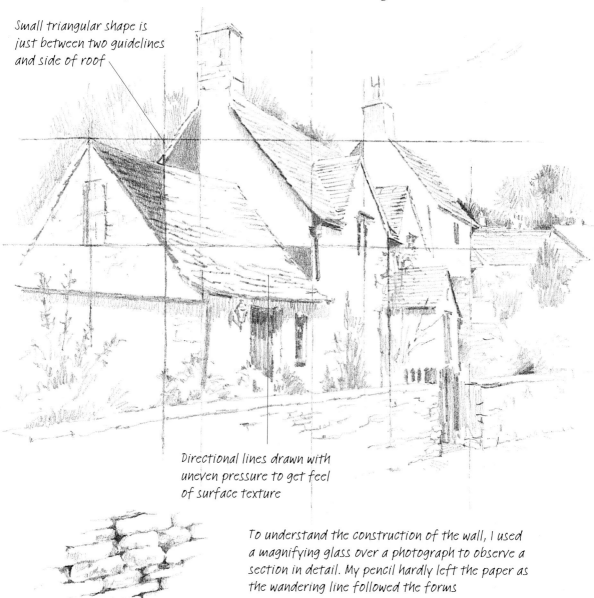

Small triangular shape is just between two guidelines and side of roof

Directional lines drawn with uneven pressure to get feel of surface texture

To understand the construction of the wall, I used a magnifying glass over a photograph to observe a section in detail. My pencil hardly left the paper as the wandering line followed the forms

You can learn a great deal by using photographs. They can help you see how the use of guidelines creates shapes between that assist with accurate placing of angles. Before working in pen and ink, plan your drawing in pencil. You can then draw over the pencil with ink before erasing it and adding the finer details.

Foliage

1. Start with an uneven line, pushing strokes upwards.

2. Pull down to form a mass.

3. Push tiny strokes (as individual marks) upwards.

4. Combine the two to form a mass with small marks at edges, suggesting individual leaves.

5. Add curved directional lines to add interest.

Tiles

Up-and-down application of directional lines can be used to suggest shadow areas on a flat surface and, when intensified, a dark recess

This line is applied with uneven pressure, backwards and forwards, to achieve the undulating effect of the tiles

Look closely at the angles to achieve correct perspective

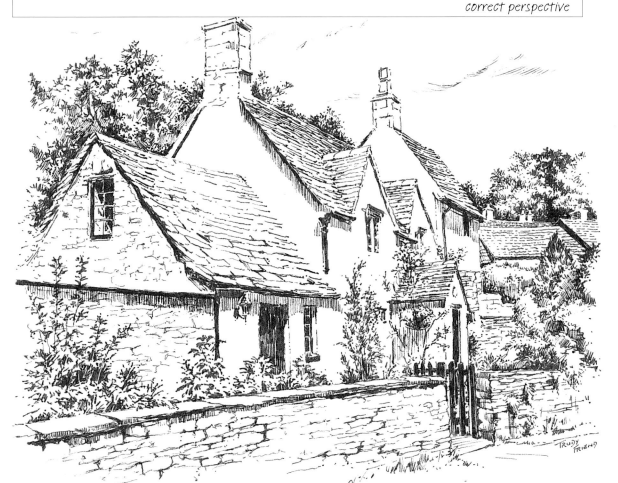

Suggest stones in the wall in places to indicate that you are aware of light hitting the surface. It is not necessary to draw every stone in detail – learn to simplify

Gardens

From tiny, one-person town enclosures to vast public areas that are tended by many hands, gardens offer artists a true wealth of subjects for drawing and painting. And it's worth considering at this point what makes a garden – plants, trees and flowers alone are only a part of the whole, and it is the planning mind of humanity, whether regularizing a garden or leaving as a wilderness, that makes the space a special one.

Some of the best garden subjects are, in fact, the man-made objects that are found in them, from classical, monumental statuary and elaborate pots and containers to humble park benches and civic fountains. Combining the natural and the artificial is a particular challenge, and requires you to use most of the techniques in the preceding themes.

Because many gardens have tall trees in a relatively enclosed space, the quality of light you are working in may be made more interesting – and more difficult – to draw by the effect of dappled sunlight. As always, observation is the key to success.

Typical Problems

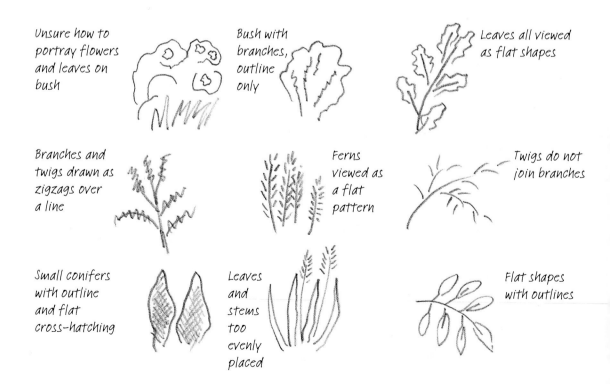

Unsure how to portray flowers and leaves on bush

Bush with branches, outline only

Leaves all viewed as flat shapes

Branches and twigs drawn as zigzags over a line

Ferns viewed as a flat pattern

Twigs do not join branches

Small conifers with outline and flat cross-hatching

Leaves and stems too evenly placed

Flat shapes with outlines

Solutions

3B pencil

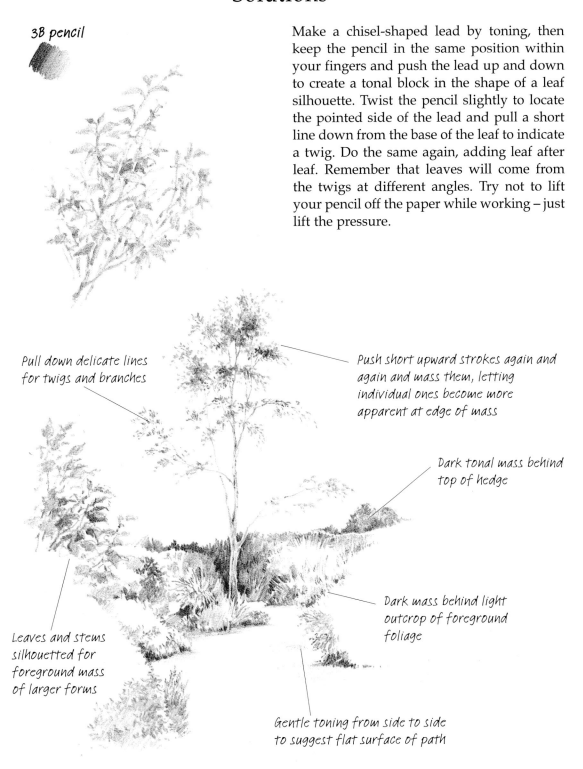

Make a chisel-shaped lead by toning, then keep the pencil in the same position within your fingers and push the lead up and down to create a tonal block in the shape of a leaf silhouette. Twist the pencil slightly to locate the pointed side of the lead and pull a short line down from the base of the leaf to indicate a twig. Do the same again, adding leaf after leaf. Remember that leaves will come from the twigs at different angles. Try not to lift your pencil off the paper while working – just lift the pressure.

Pull down delicate lines for twigs and branches

Push short upward strokes again and again and mass them, letting individual ones become more apparent at edge of mass

Dark tonal mass behind top of hedge

Dark mass behind light outcrop of foreground foliage

Leaves and stems silhouetted for foreground mass of larger forms

Gentle toning from side to side to suggest flat surface of path

Typical Problems

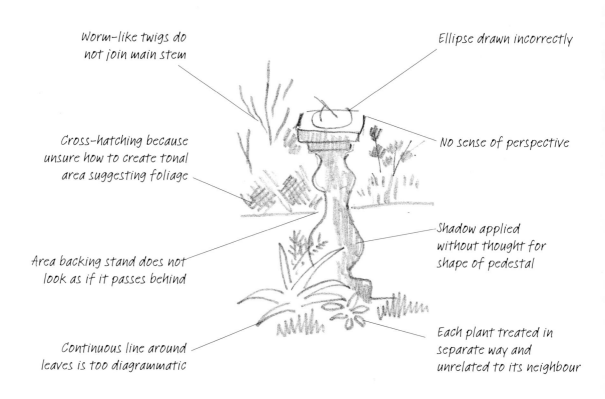

Worm-like twigs do
not join main stem

Ellipse drawn incorrectly

Cross-hatching because
unsure how to create tonal
area suggesting foliage

No sense of perspective

Area backing stand does not
look as if it passes behind

Shadow applied
without thought for
shape of pedestal

Continuous line around
leaves is too diagrammatic

Each plant treated in
separate way and
unrelated to its neighbour

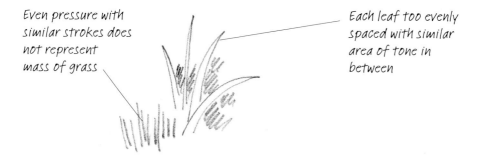

Even pressure with
similar strokes does
not represent
mass of grass

Each leaf too evenly
spaced with similar
area of tone in
between

Look closely at how plants relate to one another.
When leaves come towards you, try to leave
their shape as white paper. You can draw the
shapes very lightly and tone behind.

Solutions

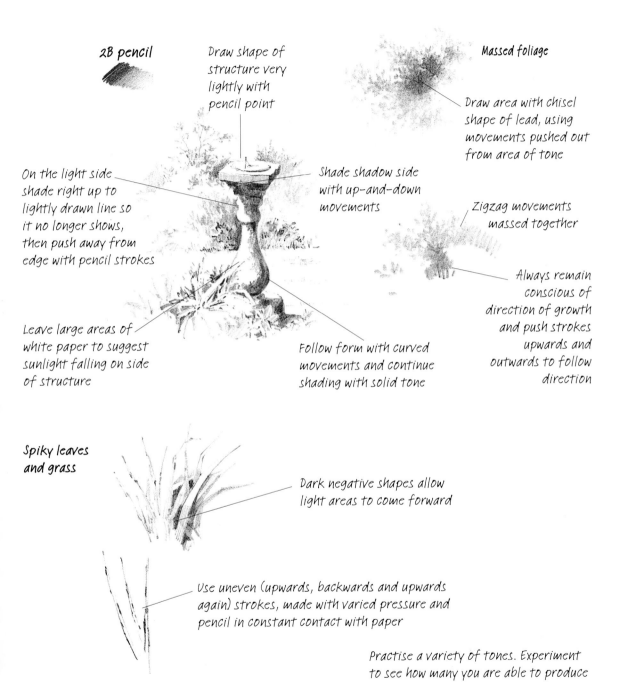

2B pencil

Draw shape of structure very lightly with pencil point

Massed foliage

Draw area with chisel shape of lead, using movements pushed out from area of tone

On the light side shade right up to lightly drawn line so it no longer shows, then push away from edge with pencil strokes

Shade shadow side with up-and-down movements

Zigzag movements massed together

Leave large areas of white paper to suggest sunlight falling on side of structure

Follow form with curved movements and continue shading with solid tone

Always remain conscious of direction of growth and push strokes upwards and outwards to follow direction

Spiky leaves and grass

Dark negative shapes allow light areas to come forward

Use uneven (upwards, backwards and upwards again) strokes, made with varied pressure and pencil in constant contact with paper

Practise a variety of tones. Experiment to see how many you are able to produce

For short grass, keep your pencil travelling as you go up and down, turning it from time to time

Typical Problems

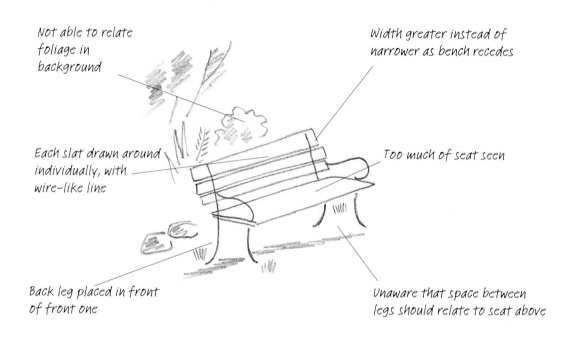

Not able to relate foliage in background

Width greater instead of narrower as bench recedes

Each slat drawn around individually, with wire-like line

Too much of seat seen

Back leg placed in front of front one

Unaware that space between legs should relate to seat above

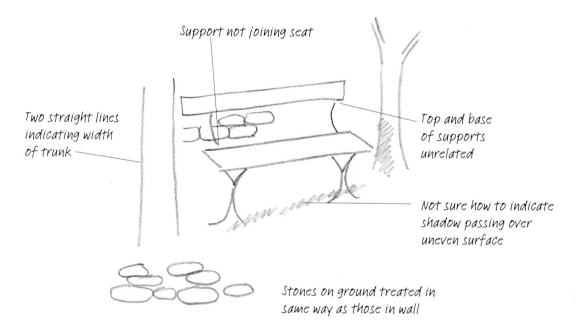

Support not joining seat

Two straight lines indicating width of trunk

Top and base of supports unrelated

Not sure how to indicate shadow passing over uneven surface

Stones on ground treated in same way as those in wall

Solutions

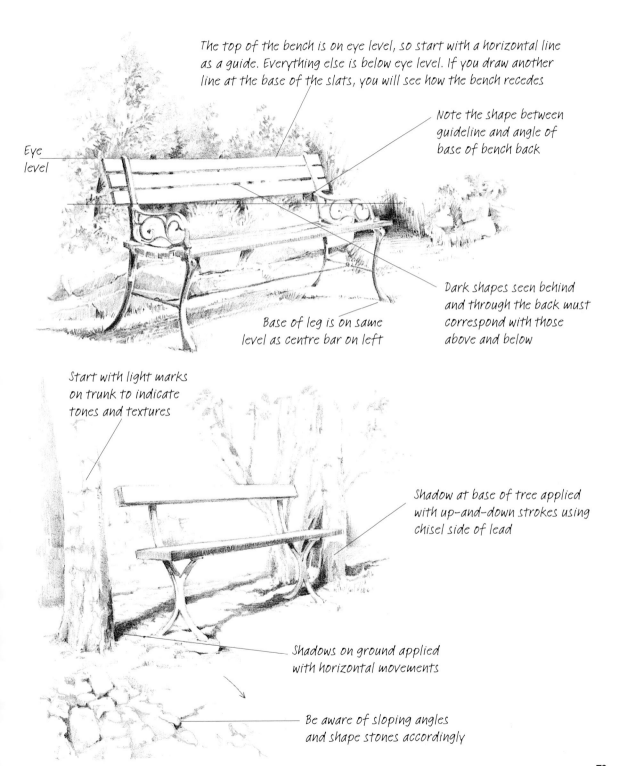

The top of the bench is on eye level, so start with a horizontal line as a guide. Everything else is below eye level. If you draw another line at the base of the slats, you will see how the bench recedes

Note the shape between guideline and angle of base of bench back

Eye level

Dark shapes seen behind and through the back must correspond with those above and below

Base of leg is on same level as centre bar on left

Start with light marks on trunk to indicate tones and textures

Shadow at base of tree applied with up-and-down strokes using chisel side of lead

Shadows on ground applied with horizontal movements

Be aware of sloping angles and shape stones accordingly

Typical Problems

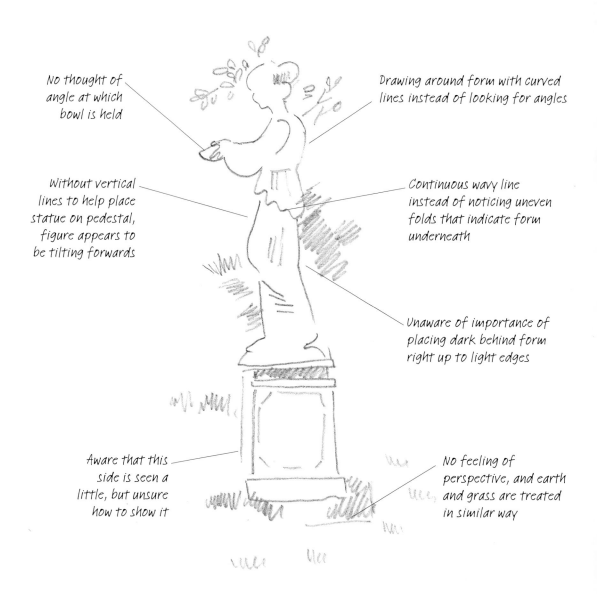

No thought of angle at which bowl is held

Drawing around form with curved lines instead of looking for angles

Without vertical lines to help place statue on pedestal, figure appears to be tilting forwards

Continuous wavy line instead of noticing uneven folds that indicate form underneath

Unaware of importance of placing dark behind form right up to light edges

Aware that this side is seen a little, but unsure how to show it

No feeling of perspective, and earth and grass are treated in similar way

Although there are no negative shapes within the statue itself, the shape between the chin, neck and outstretched arm is a very important area where you can use both horizontal and vertical guidelines.

Solutions

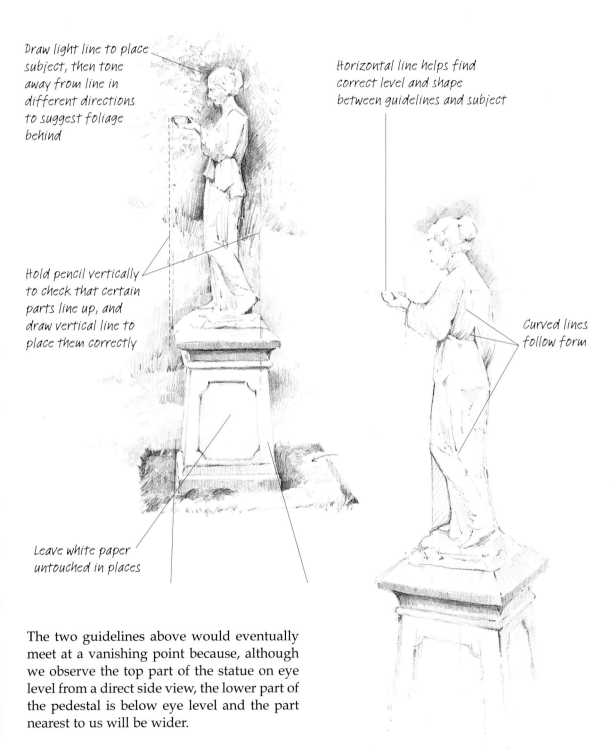

Draw light line to place subject, then tone away from line in different directions to suggest foliage behind

Horizontal line helps find correct level and shape between guidelines and subject

Hold pencil vertically to check that certain parts line up, and draw vertical line to place them correctly

Curved lines follow form

Leave white paper untouched in places

The two guidelines above would eventually meet at a vanishing point because, although we observe the top part of the statue on eye level from a direct side view, the lower part of the pedestal is below eye level and the part nearest to us will be wider.

Demonstration

I chose a little statue in the corner of a garden as a focal point. If you find the statue too complicated, you could substitute the sundial for it on page 71, set at eye level.

Make a rough sketch to position the figure and decide where to place the important dark areas behind. These will make the structure stand forward

Using uneven pressure, and slightly erratic movements, draw leaves freely in green coloured pencil

Using another colour or graphite pencil, shade in negative shapes between stalks and leaves

If you use strong side light, draw dark masses behind the light side of the form and light areas as contrast behind dark (shadow) side

Lightly draw the subject and then work around it using directional strokes

Decide which drawing materials will suit your subject. I chose an illustration cartridge, a line surface paper that is ideal for pen and ink drawing. It also produces a pleasing texture when pencil (coloured or graphite) is used.

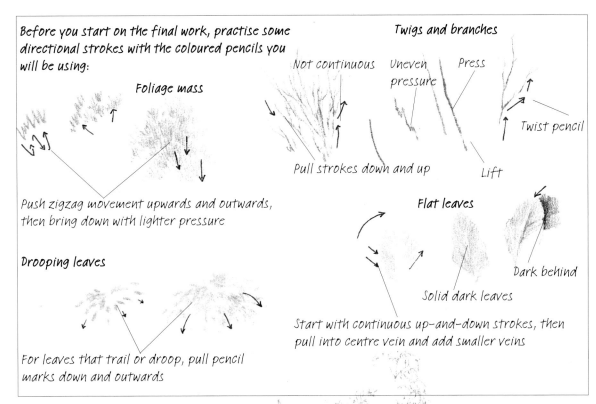

Before you start on the final work, practise some directional strokes with the coloured pencils you will be using:

Foliage mass

Push zigzag movement upwards and outwards, then bring down with lighter pressure

Drooping leaves

For leaves that trail or droop, pull pencil marks down and outwards

Twigs and branches

Not continuous Uneven Press
 pressure

Twist pencil

Pull strokes down and up Lift

Flat leaves

Dark behind

Solid dark leaves

Start with continuous up-and-down strokes, then pull into centre vein and add smaller veins

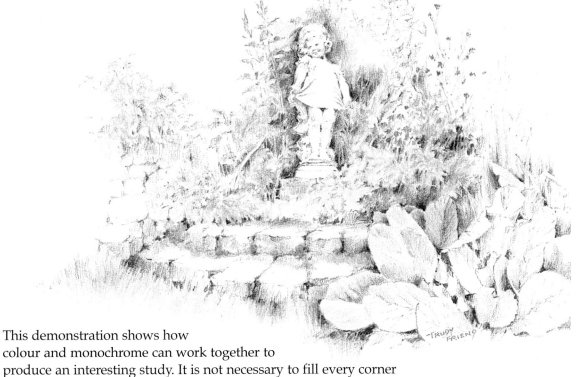

This demonstration shows how colour and monochrome can work together to produce an interesting study. It is not necessary to fill every corner of your picture – untouched white paper can enhance your drawing.

Plants and Flowers

In the themes up to now, I have looked at plants and flowers as part of the landscape, and have treated them more as masses of shape and colour than as individual objects. This section moves the emphasis from drawing landscapes to still lifes, and enables you to observe flowers in detail and gain the confidence to draw them accurately.

It is always helpful to draw the negative shapes, whatever the subject, when placing objects or parts of objects in relation to each other. I also look for what I call the other 'shapes between' – in some cases, they are shapes between part of an object and a guideline, rather than negative shapes.

You may find it helpful to work from a photograph in order to understand where to place guidelines. With practice, however, you can learn how to hold your pencil in the air in front of a view or objects and imagine where the vertical and horizontal guidelines would be placed.

Typical Problems

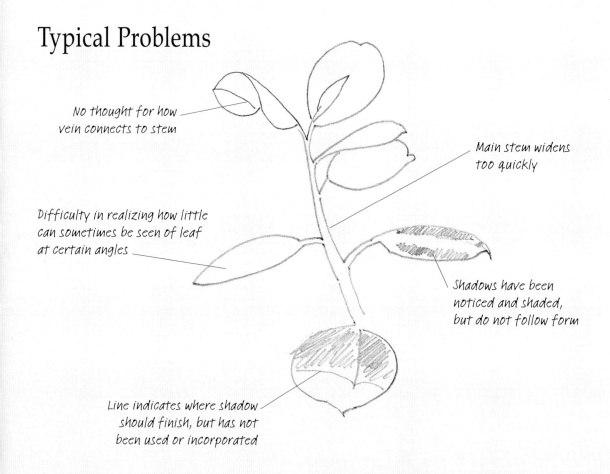

No thought for how vein connects to stem

Main stem widens too quickly

Difficulty in realizing how little can sometimes be seen of leaf at certain angles

Shadows have been noticed and shaded, but do not follow form

Line indicates where shadow should finish, but has not been used or incorporated

Solutions

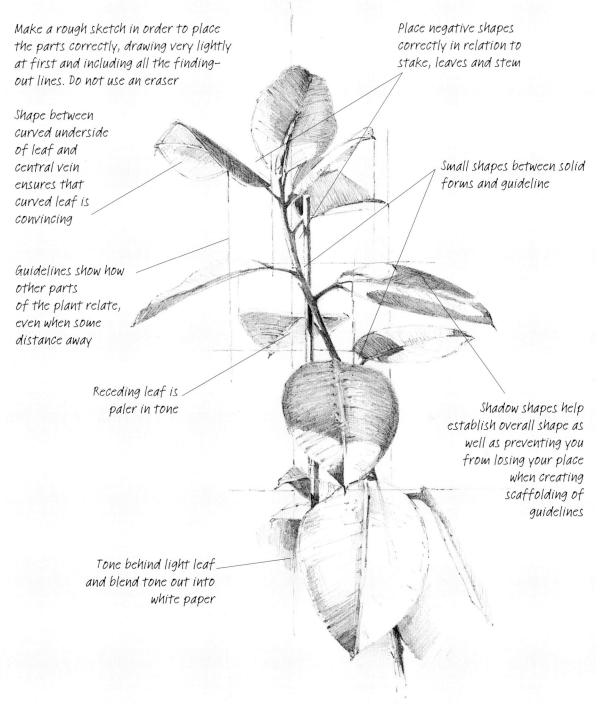

Make a rough sketch in order to place the parts correctly, drawing very lightly at first and including all the finding-out lines. Do not use an eraser

Place negative shapes correctly in relation to stake, leaves and stem

Shape between curved underside of leaf and central vein ensures that curved leaf is convincing

Small shapes between solid forms and guideline

Guidelines show how other parts of the plant relate, even when some distance away

Receding leaf is paler in tone

Shadow shapes help establish overall shape as well as preventing you from losing your place when creating scaffolding of guidelines

Tone behind light leaf and blend tone out into white paper

I do not use angled guidelines, as they may be incorrect – all are vertical or horizontal and can be checked with a set square if necessary.

Practise drawing all guidelines freehand. They may run the length of your study or remain short to compare close relationships.

Typical Problems

Each petal placed at different levels with no thought for structure or how it relates to stem

Lines to suggest edges of petals are equidistant, suggesting flat row rather than rounded form

Tendency to place subjects on same level, side by side, rather than placing one slightly in front of the other, at different level

Unsure how to suggest mass of leaves and stems

Unsure how to relate leaf to stem

Lack of thought concerning thickness of stem

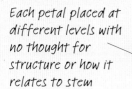

Line depicting leaf shape is uninteresting, suggesting flat pattern shape rather than three-dimensional form

Line from leaf is in front of stem, and area of tone is carelessly placed

All tonal areas treated in same way, without an understanding of how to use tone to follow form

The grade of pencil used was unsuited to the scale of this study, and was also not sharpened to a point.

Solutions

Tulip

HB pencil

Irregular dark line used for red edge of yellow tulip

Lines follow form of petals and are curved, with more pressure applied to shadow areas

Tone dark behind light area, to suggest that stem is in front of leaf — there will then be no need for line on light side of stem

Start drawing line for one side of stem with short strokes, going back over previous one a little before extending to create next one

Thicken line with gradated tone and finish with lightly applied irregular line on other side

Draw a light line through stem in order to place leaf correctly on other side

Use directional strokes to suggest curve of leaf

Look at this area as shape, and place it correctly as guide for angle of leaf

Stem above is narrower than stem below where leaf joins and base cups upper stem

Typical Problems

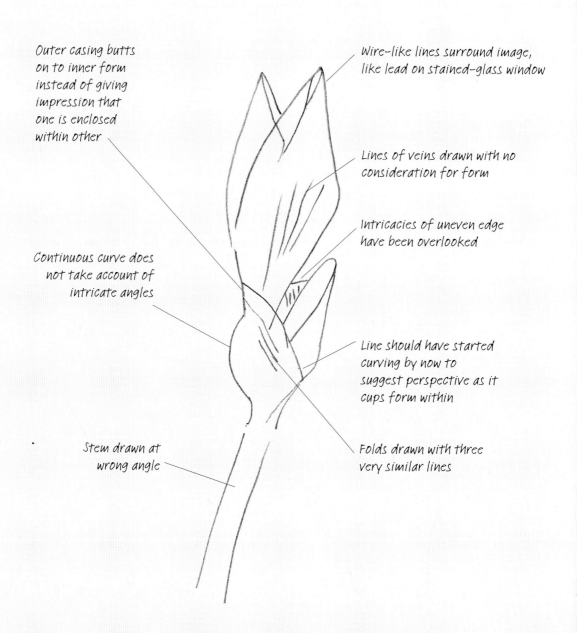

Outer casing butts on to inner form instead of giving impression that one is enclosed within other

Wire-like lines surround image, like lead on stained-glass window

Lines of veins drawn with no consideration for form

Intricacies of uneven edge have been overlooked

Continuous curve does not take account of intricate angles

Line should have started curving by now to suggest perspective as it cups form within

Stem drawn at wrong angle

Folds drawn with three very similar lines

Within the form of an Iris you will find many aspects to learn from. Study small areas, practising line and tone variations (with on/off pressure of your pencil) before drawing the flower in its entirety.

Solutions

Iris

B graphite pencil

Start with a small shape, then another, larger shape. Move on to next shape, relating each one to other and using fine veins as lines to find form

In some places you will be able to see through translucent areas

Practise different line formations within shape of flower

Cut in crisply with tone to make light areas stand forward

Note details, such as succulent bud enclosed within translucent, finely veined cover

Always think of what is enclosed and, with your knowledge of what happens, you will make your drawing convincing

Practise details in order to understand how each part is made up, and work line and tone together

For dense shading, start with very light application (using chisel side of pencil) and gently work over and over same area to build tone up to desired intensity

The pencil should hardly leave the surface of the paper at all when drawing. The tip of the pencil is a fine point that travels over the paper's surface, lightly changing direction as necessary to describe the contours.

Typical Problems

A flower of this nature is delicate so, when making a drawing that is the actual size of the plant, many people resort to outline only.

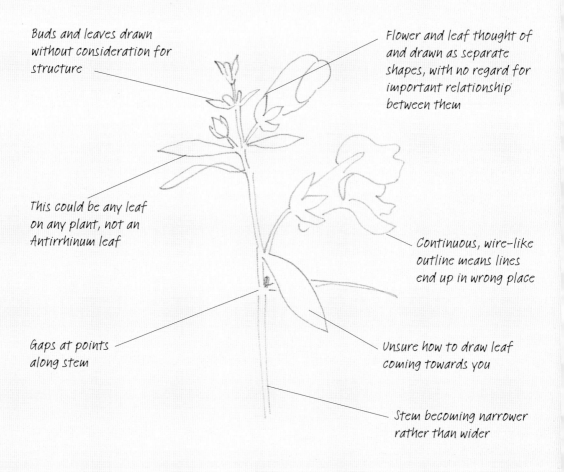

Buds and leaves drawn without consideration for structure

Flower and leaf thought of and drawn as separate shapes, with no regard for important relationship between them

This could be any leaf on any plant, not an Antirrhinum leaf

Continuous, wire-like outline means lines end up in wrong place

Gaps at points along stem

Unsure how to draw leaf coming towards you

Stem becoming narrower rather than wider

While learning to draw plants, it is sometimes helpful if you gently remove some of the flower heads to enable you to see the remaining ones clearly. This also makes it easier to observe the structure of stem and leaf placing. By removing a couple of larger blooms, you may be able to use clear negative spaces to advantage.

Solutions

Antirrhinum

Making tone and line work together:

This side of the leaf can remain as white paper or receive a light tone

This side is just a dark shape

Start here and draw shape with downward curved line on into stem

Draw negative shapes to place base of flower, stem and leaf accurately in relation to each other

To draw the stem:

(a) Establish the bud shape in relation to the adjoining leaf.
(b) Draw a downward line firmly. This will be the shadow side of the stem.
(c) Make the line wider (on the left side), gradually reducing pressure to lighten tone.

Add pressure to darken tone, as width is established, with hardly any pressure towards light side

Remember your constructive doodles? These on/off lines, used on the flower, are applied in the same way

To shade veins on a leaf:

(a) Shade gently away from crisp edges.

(b) Place another crisp edge a small distance away from the first, and gently shade out from there.

Choose any flower that you consider complicated to draw. You will need to observe it far more carefully if you are unfamiliar with the shape and form, especially the negative shapes and other shapes between, to enable you to be accurate.

Demonstration

The Iris is one of the most helpful plants to draw when looking for shapes and form. Here is an open bloom, following on from the bud on page 83. This page shows how the first drawing develops and, in this instance, how the first shape drawn is at the top.

1. Draw the shape, and tone it, with directional strokes (as it appears in shadow).

2. Add the larger shape.

3. Slowly a relationship develops between the petals and, with the aid of directional strokes to follow the form, work down.

A wandering line (with on/off pressure) finds the edge of the petal and relates to the undulations within

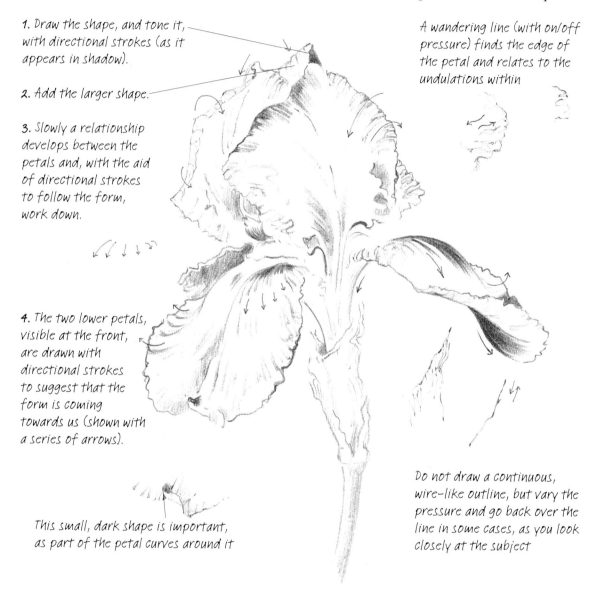

4. The two lower petals, visible at the front, are drawn with directional strokes to suggest that the form is coming towards us (shown with a series of arrows).

This small, dark shape is important, as part of the petal curves around it

Do not draw a continuous, wire-like outline, but vary the pressure and go back over the line in some cases, as you look closely at the subject

At all times check and double-check the tiny undulations at the edges of petals, relationships between the petals and directional strokes suggesting form. In this case I held the flower in one hand – alongside the drawing – and continuously looked from one to the other. Always keep checking for accuracy in order to develop drawing and observation skills.

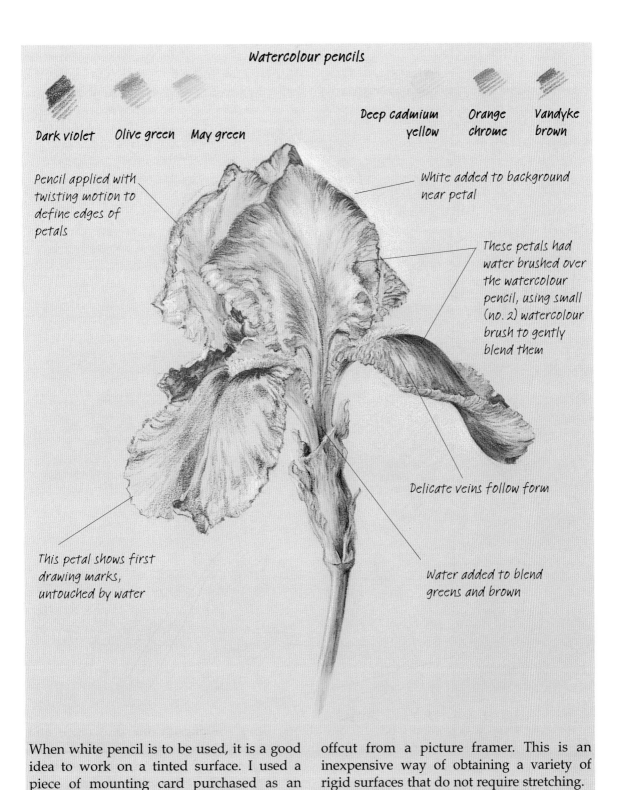

Watercolour pencils

Dark violet Olive green May green

Deep cadmium Orange Vandyke
yellow chrome brown

Pencil applied with
twisting motion to
define edges of
petals

White added to background
near petal

These petals had
water brushed over
the watercolour
pencil, using small
(no. 2) watercolour
brush to gently
blend them

Delicate veins follow form

This petal shows first
drawing marks,
untouched by water

Water added to blend
greens and brown

When white pencil is to be used, it is a good idea to work on a tinted surface. I used a piece of mounting card purchased as an offcut from a picture framer. This is an inexpensive way of obtaining a variety of rigid surfaces that do not require stretching.

Vegetables

Vegetables and fruit, although they may be still-life subjects that we do not normally think of drawing, provide us with marvellous opportunities to observe structure and form, and the examples in this theme show in particular how reflected light enhances form in drawing.

I never tire of drawing mushrooms, for instance, as they give opportunities for line and tone to work together to describe form and encourage the use of contrasts. Many vegetables and fruits show similarities with other totally different subjects, and allow you to make use of shadow shapes and shadow lines in drawings.

It is important to choose the right materials to work together for certain subjects. The chunky feel of the mushrooms can encourage you to use a soft pencil, and to work on rough-textured (and possibly off-white or tinted) paper in order to achieve more texture. A smooth paper is more suitable for delicate work on subjects such as tomato stalks and peas or beans.

Typical Problems

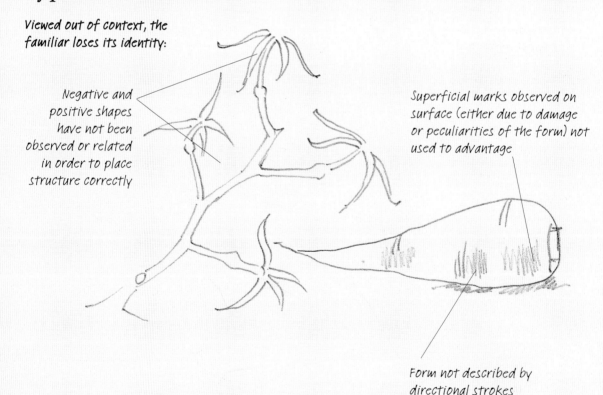

Viewed out of context, the familiar loses its identity:

Negative and positive shapes have not been observed or related in order to place structure correctly

Superficial marks observed on surface (either due to damage or peculiarities of the form) not used to advantage

Form not described by directional strokes

Solutions

Observing Structure and Form

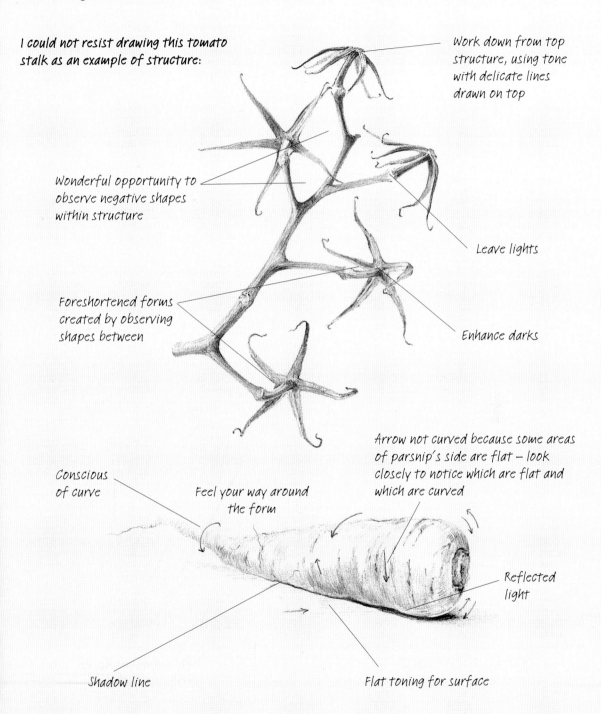

I could not resist drawing this tomato stalk as an example of structure:

Work down from top structure, using tone with delicate lines drawn on top

Wonderful opportunity to observe negative shapes within structure

Leave lights

Foreshortened forms created by observing shapes between

Enhance darks

Arrow not curved because some areas of parsnip's side are flat – look closely to notice which are flat and which are curved

Conscious of curve

Feel your way around the form

Reflected light

Shadow line

Flat toning for surface

Typical Problems

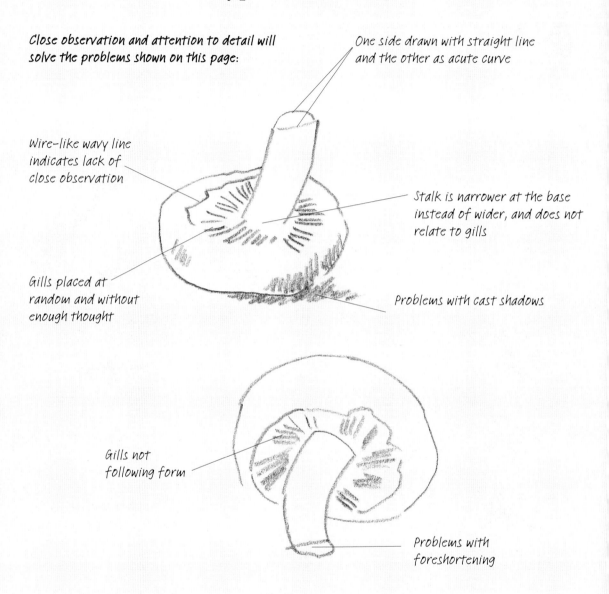

Close observation and attention to detail will solve the problems shown on this page:

One side drawn with straight line and the other as acute curve

Wire-like wavy line indicates lack of close observation

Stalk is narrower at the base instead of wider, and does not relate to gills

Gills placed at random and without enough thought

Problems with cast shadows

Gills not following form

Problems with foreshortening

Many problems may be due to not knowing how to tone around the form. Try to imagine a little spider walking over the surface – it would follow the direction of the arrows shown on page 91. If, as you look at the mushroom in front of you, you can imagine the tiny creature's progress (and let your pencil wander in the same directions), you will find you are beginning to use a wandering line to describe form.

Solutions

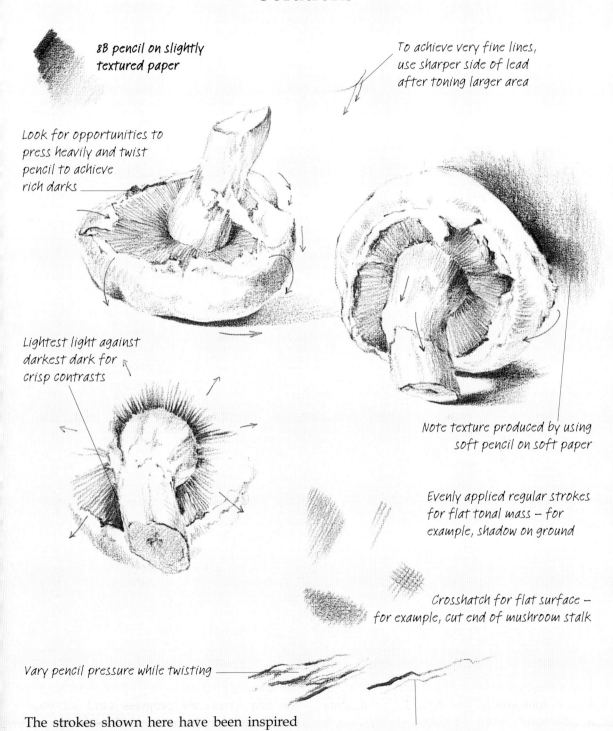

8B pencil on slightly textured paper

To achieve very fine lines, use sharper side of lead after toning larger area

Look for opportunities to press heavily and twist pencil to achieve rich darks

Lightest light against darkest dark for crisp contrasts

Note texture produced by using soft pencil on soft paper

Evenly applied regular strokes for flat tonal mass – for example, shadow on ground

Crosshatch for flat surface – for example, cut end of mushroom stalk

Vary pencil pressure while twisting

The strokes shown here have been inspired by surface textures on a mushroom, but they can also be applied to many other subjects.

Twist as you travel for thick and very thin lines

Typical Problems

Many vegetables, when cut or opened out to reveal seeds within, can be used as subjects worthy of our close observation, allowing us to understand form and texture.

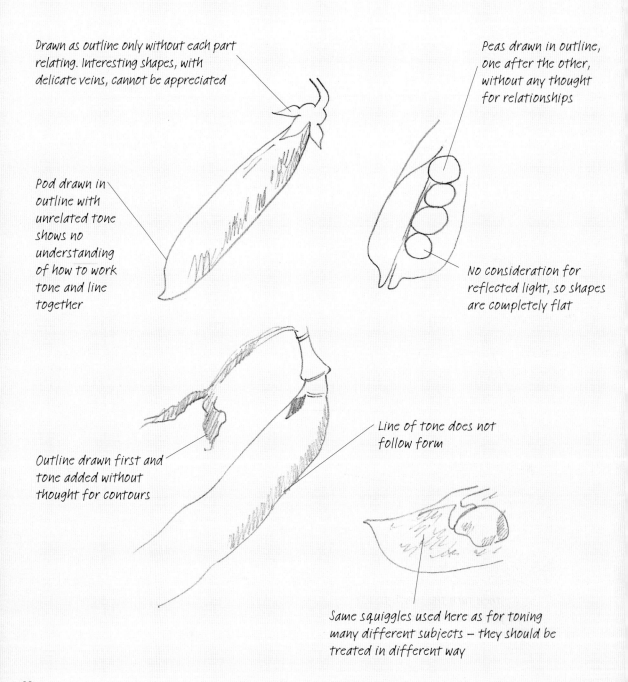

Drawn as outline only without each part relating. Interesting shapes, with delicate veins, cannot be appreciated

Peas drawn in outline, one after the other, without any thought for relationships

Pod drawn in outline with unrelated tone shows no understanding of how to work tone and line together

No consideration for reflected light, so shapes are completely flat

Outline drawn first and tone added without thought for contours

Line of tone does not follow form

Same squiggles used here as for toning many different subjects – they should be treated in different way

Solutions

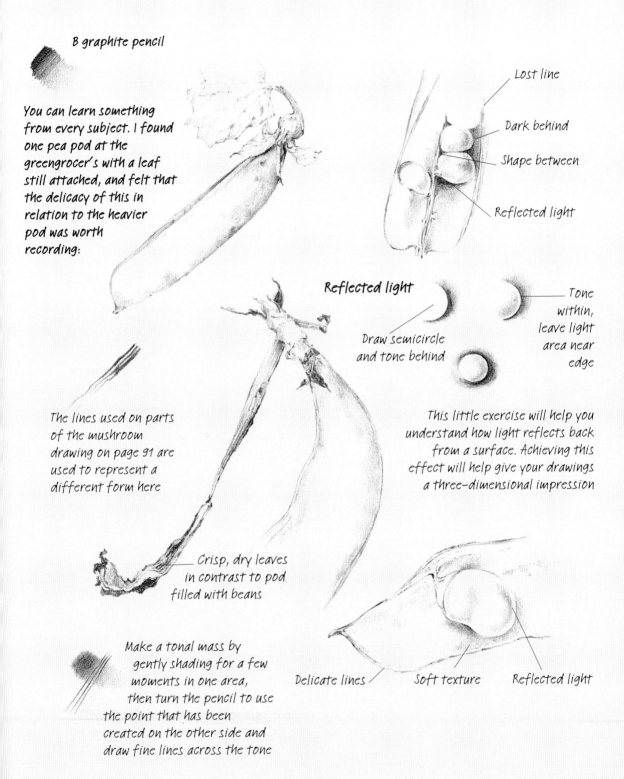

B graphite pencil

You can learn something from every subject. I found one pea pod at the greengrocer's with a leaf still attached, and felt that the delicacy of this in relation to the heavier pod was worth recording:

Lost line

Dark behind

Shape between

Reflected light

Reflected light

Tone within, leave light area near edge

Draw semicircle and tone behind

The lines used on parts of the mushroom drawing on page 91 are used to represent a different form here

This little exercise will help you understand how light reflects back from a surface. Achieving this effect will help give your drawings a three-dimensional impression

Crisp, dry leaves in contrast to pod filled with beans

Delicate lines Soft texture Reflected light

Make a tonal mass by gently shading for a few moments in one area, then turn the pencil to use the point that has been created on the other side and draw fine lines across the tone

93

Demonstration

The wax content of the artists' pencils used here causes them to travel smoothly over the textured paper surface. Few colours are used, and all the initial drawing is done in Chocolate.

Arrange the vegetables to guide the eye into the composition and establish interesting shapes between. The block of wood behind the leek is actually beyond another small block on which the onion and potato rest. It is placed at an angle, and follows the line of the leek.

The positions of the various vegetables are established with the use of guidelines (a couple of which I have emphasized, to show how they were placed in relation to visual contact points)

Most of the guidelines are drawn so lightly that they are not obvious in the finished work, but I did place much darker tones for the tiny shapes between, which I felt to be so vital within this composition.

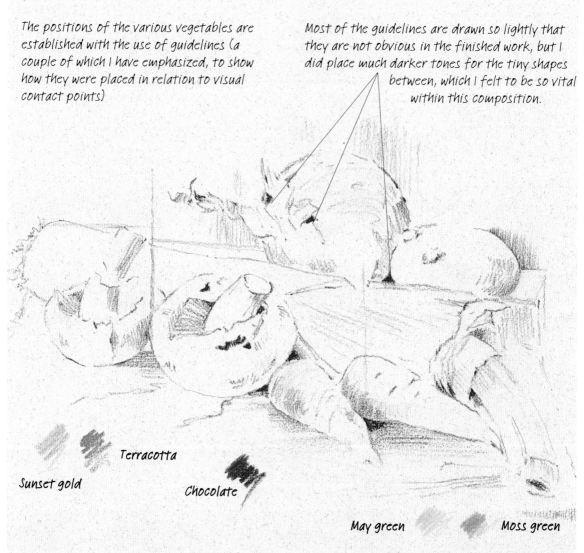

Terracotta

Sunset gold

Chocolate

May green

Moss green

The group, placed on a slate floor tile, has a piece of wood at the back with a noticeable grain. This dictated the up-and-down strokes used on that surface. All pencil strokes on the toned areas are directional to follow the form

Place the warm colours first and then introduce the greens of the leek. White is used gently for the highlights

Demonstration

For this group, I chose a slightly textured, tinted paper, intending to use its colour and allowing it to be part of the overall effect and to influence the way light areas were treated.

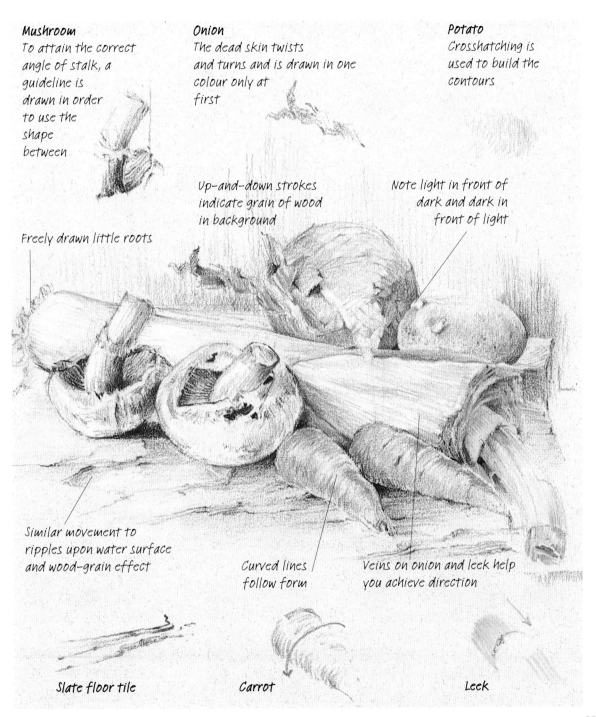

Mushroom
To attain the correct angle of stalk, a guideline is drawn in order to use the shape between

Onion
The dead skin twists and turns and is drawn in one colour only at first

Potato
Crosshatching is used to build the contours

Up-and-down strokes indicate grain of wood in background

Note light in front of dark and dark in front of light

Freely drawn little roots

Similar movement to ripples upon water surface and wood-grain effect

Curved lines follow form

Veins on onion and leek help you achieve direction

Slate floor tile

Carrot

Leek

Textures

Whatever your chosen subject, if you wish to make intricate, detailed drawings, one of the best ways to learn is to look closely at, and practise drawing, textured surfaces.

Try to observe and produce a variety of effects. Even sitting at a table made of pine or another wood with an interesting grain, or studying a piece of wood offcut, will provide interesting textures. By attempting to draw a small section, looking closely at the grain, you can produce a series of studies from which you can learn many techniques.

The same applies to pieces of stone of all sizes. In the following pages I suggest a few warm-up exercises to try with the pencil before you start work in earnest.

Items of clothing, either worn by a person, placed on a surface or hanging from a hook, provide interesting subjects for learning studies, and still-life studies often have cloth within them or as a background. You can set up endless still-life arrangements using everyday objects, all of which will have a slightly different surface texture.

Typical Problems

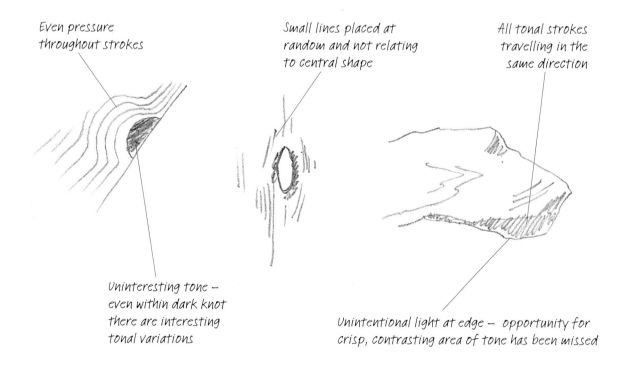

Even pressure throughout strokes

Small lines placed at random and not relating to central shape

All tonal strokes travelling in the same direction

Uninteresting tone – even within dark knot there are interesting tonal variations

Unintentional light at edge – opportunity for crisp, contrasting area of tone has been missed

Solutions

Wood

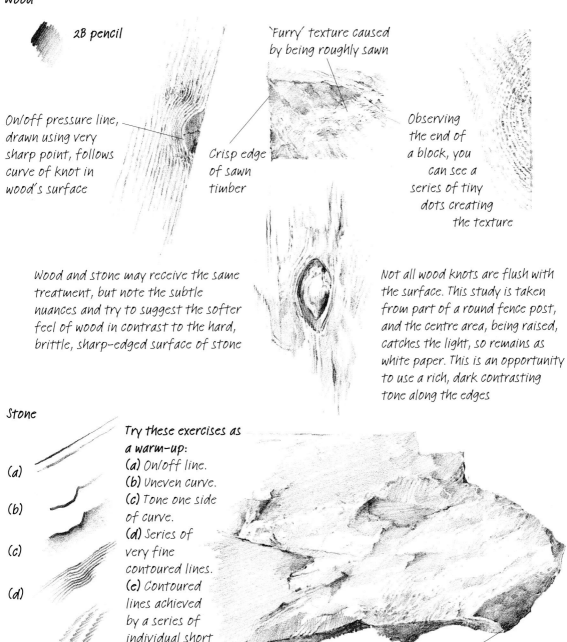

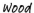 2B pencil

'Furry' texture caused by being roughly sawn

On/off pressure line, drawn using very sharp point, follows curve of knot in wood's surface

Crisp edge of sawn timber

Observing the end of a block, you can see a series of tiny dots creating the texture

Wood and stone may receive the same treatment, but note the subtle nuances and try to suggest the softer feel of wood in contrast to the hard, brittle, sharp-edged surface of stone

Not all wood knots are flush with the surface. This study is taken from part of a round fence post, and the centre area, being raised, catches the light, so remains as white paper. This is an opportunity to use a rich, dark contrasting tone along the edges

Stone

(a)

(b)

(c)

(d)

(e)

Try these exercises as a warm-up:
(a) On/off line.
(b) Uneven curve.
(c) Tone one side of curve.
(d) Series of very fine contoured lines.
(e) Contoured lines achieved by a series of individual short lines.

Go for rich darks when you have opportunity

Make up your own exercises of constructive doodles, suggested by close observation of textured surfaces.

Typical Problems

The chance to observe a number of textures within one study has been missed. Look at the smooth, hard, shiny surface of the hook, in contrast to the smooth fabric used as tape, against the rough texture of the pile of the dressing gown. The fabric-covered button (where tightly stretched cloth offers an opportunity to crosshatch) contrasts with the small area of decorated braid that follows the form.

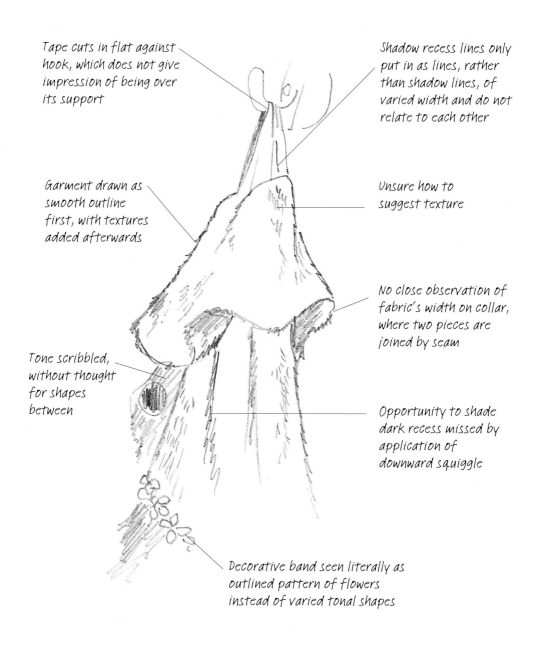

Tape cuts in flat against hook, which does not give impression of being over its support

Shadow recess lines only put in as lines, rather than shadow lines, of varied width and do not relate to each other

Garment drawn as smooth outline first, with textures added afterwards

Unsure how to suggest texture

No close observation of fabric's width on collar, where two pieces are joined by seam

Tone scribbled, without thought for shapes between

Opportunity to shade dark recess missed by application of downward squiggle

Decorative band seen literally as outlined pattern of flowers instead of varied tonal shapes

Solutions

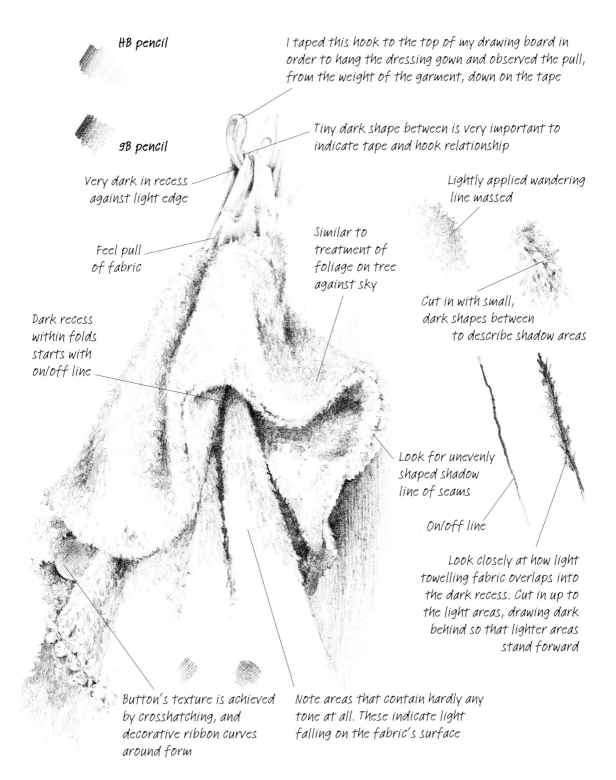

HB pencil

9B pencil

I taped this hook to the top of my drawing board in order to hang the dressing gown and observed the pull, from the weight of the garment, down on the tape

Tiny dark shape between is very important to indicate tape and hook relationship

Very dark in recess against light edge

Lightly applied wandering line massed

Feel pull of fabric

Similar to treatment of foliage on tree against sky

Cut in with small, dark shapes between to describe shadow areas

Dark recess within folds starts with on/off line

Look for unevenly shaped shadow line of seams

On/off line

Look closely at how light towelling fabric overlaps into the dark recess. Cut in up to the light areas, drawing dark behind so that lighter areas stand forward

Button's texture is achieved by crosshatching, and decorative ribbon curves around form

Note areas that contain hardly any tone at all. These indicate light falling on the fabric's surface

Typical Problems

Many beginners experience problems with fabric when trying to give the impression of folds. They draw lines and add areas of tone, only to find that they do not work together, producing a series of marks rather than the feel of folded cloth.

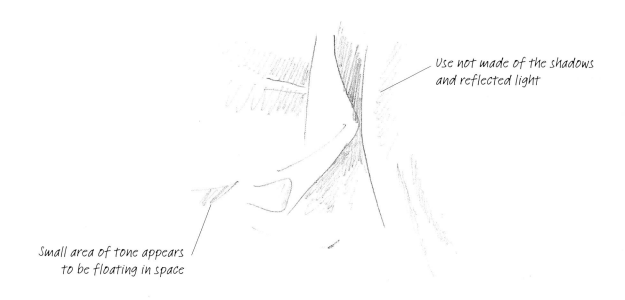

Use not made of the shadows and reflected light

Small area of tone appears to be floating in space

Problems with creating recess

Tone is a very important part of this type of drawing. I always work my line and tone together in order to create crisp contrasts at the edges and gentle blending on the contoured and curved surfaces

There is no need to practise larger areas than those on page 101 when you are at first learning to look. If one study goes wrong, just leave it and start another. Try not to be tempted to erase and correct the study – it is better to leave your mistakes in order to learn from them. Compare the two and observe your progress.

Solutions

Folds

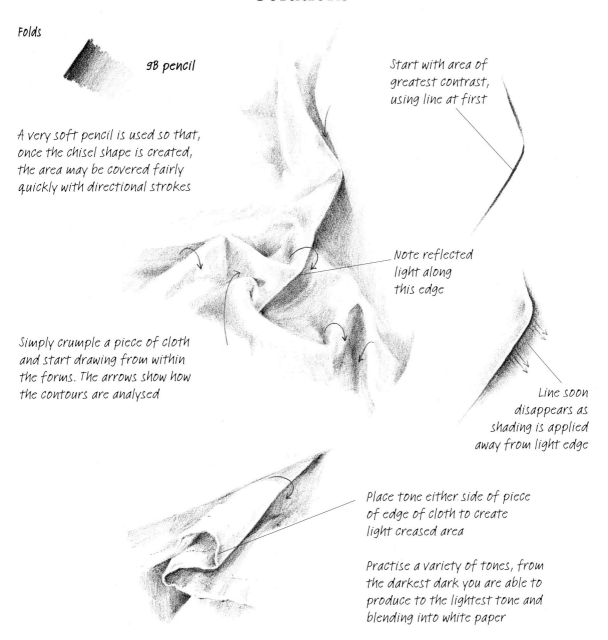

9B pencil

A very soft pencil is used so that, once the chisel shape is created, the area may be covered fairly quickly with directional strokes

Start with area of greatest contrast, using line at first

Note reflected light along this edge

Simply crumple a piece of cloth and start drawing from within the forms. The arrows show how the contours are analysed

Line soon disappears as shading is applied away from light edge

Place tone either side of piece of edge of cloth to create light creased area

Practise a variety of tones, from the darkest dark you are able to produce to the lightest tone and blending into white paper

Looking at pieces of cloth and the way the folds cause shadows is a good way to practise toning. Remember to follow the form.

Demonstration

I chose a simple coffee cup and saucer for this demonstration, but added other items to cut across forms in order to help explain shadow shapes, the effective use of grid and guidelines, relationships, contrasts and darks behind.

I started by placing the spoon in relationship to the ellipse of the cup, paying particular attention to the shape between and the shadow shape reflected on the inner surface. I then worked down the right side to place the handle in relationship to any background seen behind or through the form. Starting to work across, on the curve of the dark band, I was intrigued by the shapes between the base of the cup and the saucer upon which it rests. Horizontal and vertical guidelines assisted with accurate placing of overlapping forms.

I placed a sheet of paper on which I had drawn a number of squares behind the group. This rigid grid is a great help, but notice also my 'personal grid' created by numerous guidelines that help position objects correctly in relation to each other

The arrows indicate that there were three light sources. It is also a good idea to practise with just one source of light

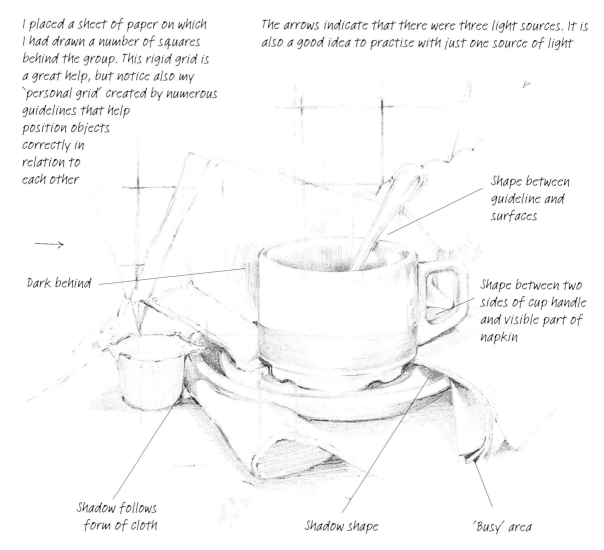

Shape between guideline and surfaces

Dark behind

Shape between two sides of cup handle and visible part of napkin

Shadow follows form of cloth

Shadow shape

'Busy' area

Demonstration

There were two stages to this study. In my initial rough drawing I drew as many guidelines as were needed in order to place objects correctly. Then I attached the rough to a window pane, using masking tape, and placed a separate sheet of paper over it. The main lines were clear to see and I traced the basic outlines, not as continuous, diagrammatic lines, but in a gentle way, as if drawing them for the first time. Sitting again in front of the still-life group, I then added colour and tone. I kept the rough drawing to hand and referred to it from time to time.

Mixed textures

A limited coloured range was chosen, using Derwent Studio coloured pencils, which are ideal for blending and mixing for overworking shadows and highlights

Gunmetal used for spoon, cup, doily and cloth

Red napkin is reflected in surface of cup

Gentle toning of darker area behind cup brings form forward

Gentle blending builds up layers of tone and colour

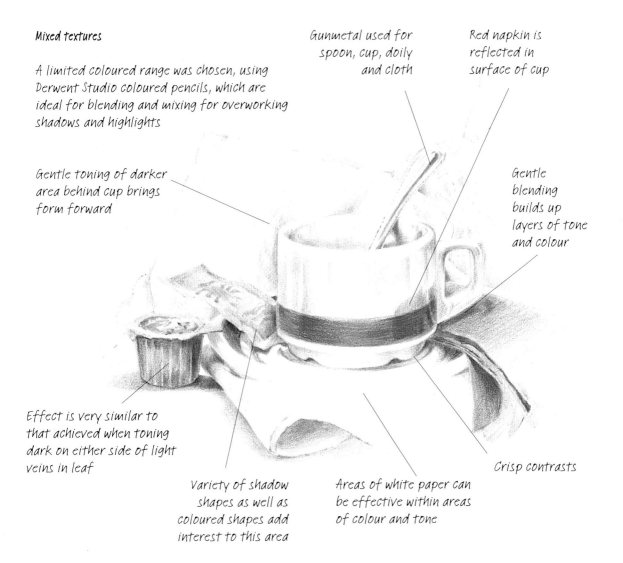

Effect is very similar to that achieved when toning dark on either side of light veins in leaf

Variety of shadow shapes as well as coloured shapes add interest to this area

Areas of white paper can be effective within areas of colour and tone

Crisp contrasts

Pets

Whether making quick sketches of pets from life, or more detailed drawings with the aid of photographs, your primary considerations should be close observation and a feeling for the subject. On location, I spent much more time observing the dogs on the opposite page than I did drawing them – and these are only a few of the studies that I made that day!

It is also my previous knowledge and understanding of the subject, achieved by a lifelong interest in animals, that influences the way I interpret them in their various stances. If your interest lies with animal drawing, it could well be because the animals themselves mean so much to you. This feeling will help you enormously.

If you apply the methods of drawing and observation covered in this book (especially the three important 'P's – Practice, Patience and Perseverance) and combine them with an instinctive knowledge of animals, you will discover your talents emerging.

As with most subjects, particularly ones that are everyday or familiar to you, try not to judge yourself too harshly or to look for rapid progress. Take your time and notice your improvements (however small) – and be encouraged by them.

Typical Problems

Proportions of head, tongue etc are promising – as are those in the body

Eyes incorrectly drawn, without close observation

Interesting line not following through

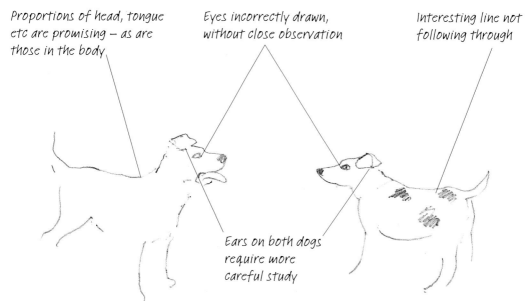

Ears on both dogs require more careful study

As quick sketches worked by a beginner, these make a good start, and the problem areas can be addressed by developing a deeper understanding of the subject (looking at and thinking about it for some time) before starting to draw.

Solutions

For the top left-hand drawings I started with the dog's eye. On the middle one, it was the relationship of the ears – toned as solid shapes – before using a wandering line to find form around the neck and on into the shoulders and body.

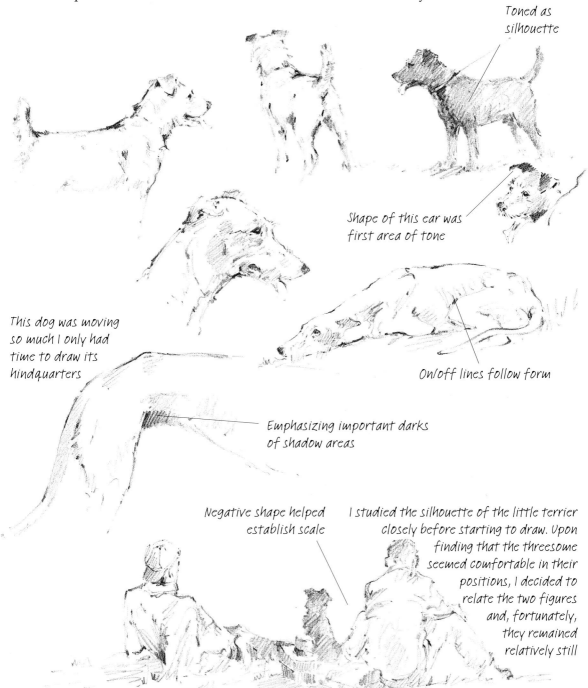

Toned as silhouette

Shape of this ear was first area of tone

This dog was moving so much I only had time to draw its hindquarters

On/off lines follow form

Emphasizing important darks of shadow areas

Negative shape helped establish scale

I studied the silhouette of the little terrier closely before starting to draw. Upon finding that the threesome seemed comfortable in their positions, I decided to relate the two figures and, fortunately, they remained relatively still

Typical Problems

As with the dog drawn by a beginner on page 28, there is a lack of understanding of how to depict the dog's eyes from an unfamiliar angle.

A useful tip is to try not to draw around the eye in one or two strokes. Instead, look for angles and draw bit by bit, observing relationships of one side to the other at every stage. See also the solutions to drawing a pony's eye on page 117.

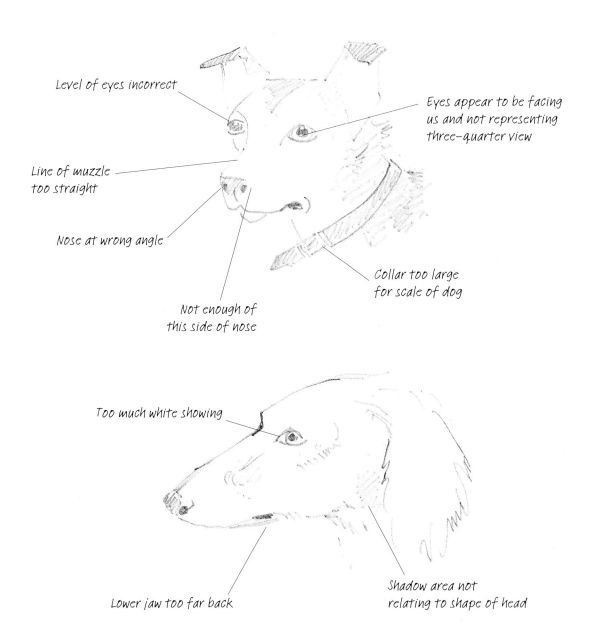

Level of eyes incorrect

Eyes appear to be facing us and not representing three-quarter view

Line of muzzle too straight

Nose at wrong angle

Collar too large for scale of dog

Not enough of this side of nose

Too much white showing

Lower jaw too far back

Shadow area not relating to shape of head

Solutions

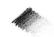

HB graphite pencil

This side of head shows
first stage of drawing,
where small shapes
between are considered
carefully

Kipper — a mixed breed. A
photograph depicting a
three-quarter view
provided ideal reference for
me to cover this angle

I have not drawn
arrows to indicate
directional strokes. Instead,
the actual strokes are heavier
in the lower part of the portrait
for you to see how I decide in
which direction to tone the hair

Firm directional strokes on
collar indicate the way it curves

Angus — a standard long-haired Dachshund

Contact point — a good place
from which to drop guideline

This aristocratic profile shows how I started my first rough.
Using guidelines to help place indentations and changes of
hair growth direction, I looked closely for any small nuances
to help place these correctly

Typical Problems

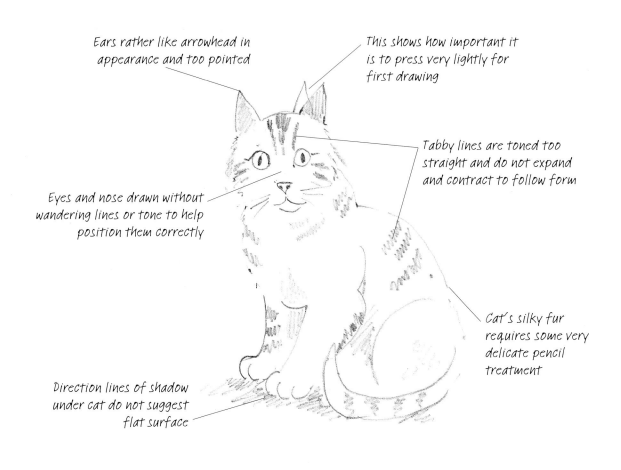

Ears rather like arrowhead in appearance and too pointed

This shows how important it is to press very lightly for first drawing

Tabby lines are toned too straight and do not expand and contract to follow form

Eyes and nose drawn without wandering lines or tone to help position them correctly

Cat's silky fur requires some very delicate pencil treatment

Direction lines of shadow under cat do not suggest flat surface

This is the way some beginners depict cat paws. I hope the drawing on page 109 shows how little outline is actually necessary

Solutions

I chose to draw a tabby cat. The markings are achieved by a similar method as that used for grass – that is, cutting in with a dark behind.

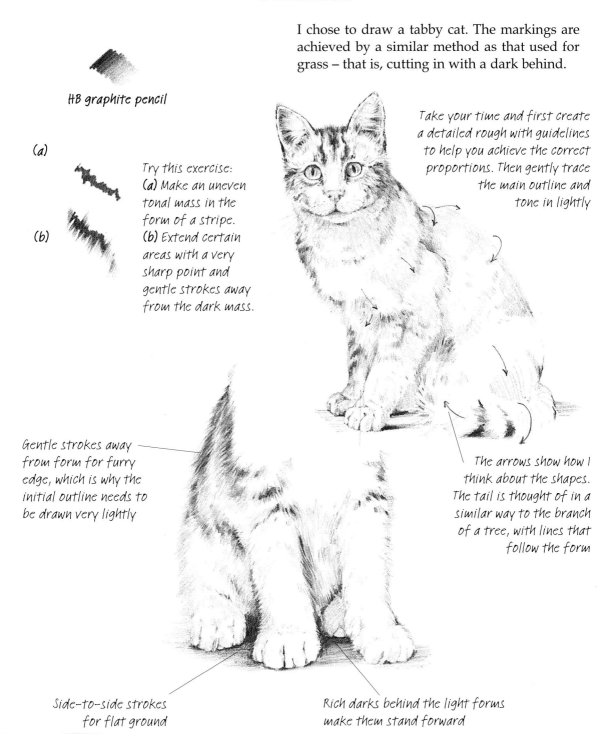

HB graphite pencil

(a)

Try this exercise:
(a) Make an uneven tonal mass in the form of a stripe.
(b) Extend certain areas with a very sharp point and gentle strokes away from the dark mass.

(b)

Take your time and first create a detailed rough with guidelines to help you achieve the correct proportions. Then gently trace the main outline and tone in lightly

Gentle strokes away from form for furry edge, which is why the initial outline needs to be drawn very lightly

The arrows show how I think about the shapes. The tail is thought of in a similar way to the branch of a tree, with lines that follow the form

Side-to-side strokes for flat ground

Rich darks behind the light forms make them stand forward

Demonstration

This portait is of a Jack Russell terrier. When portraying a particular dog, it is a good idea to draw a few details at the side of your first rough drawing. If the dog has passed away and you have to rely solely upon your memories and photographic reference, it is important to get the character details correct.

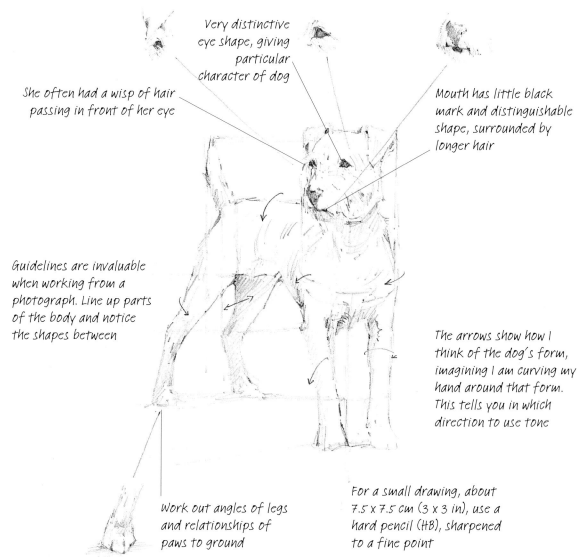

Very distinctive eye shape, giving particular character of dog

She often had a wisp of hair passing in front of her eye

Mouth has little black mark and distinguishable shape, surrounded by longer hair

Guidelines are invaluable when working from a photograph. Line up parts of the body and notice the shapes between

The arrows show how I think of the dog's form, imagining I am curving my hand around that form. This tells you in which direction to use tone

Work out angles of legs and relationships of paws to ground

For a small drawing, about 7.5 x 7.5 cm (3 x 3 in), use a hard pencil (HB), sharpened to a fine point

Beginners will find it beneficial to practise working on small studies in addition to the larger work they produce. It is a discipline that encourages concentration, close observation and exacting skills.

Meldreth

HB graphic pencil on
smooth cartridge paper

Achieving the darks for the ear:

(a) (b) (c)

(a) Draw the curved shadow shape where
the ear rests against the head.
(b) Pull down your pencil strokes, allowing
some light areas to remain.
(c) Finish with other tones.

Longer hair on the muzzle:

First strokes

Cut in with darks
behind to bring
out light hair

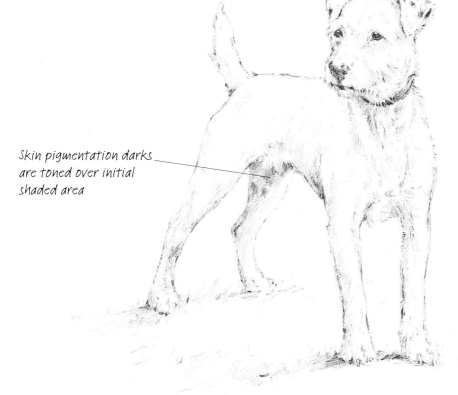

Skin pigmentation darks
are toned over initial
shaded area

The tick and flick
pencil exercises shown
for giving the
impression of grass on
page 61 are very similar
to those used when
representing hair

Always be conscious of the form and direction of hair growth.
Avoid a hard outline. When a white dog is depicted against a
white background, you need edges, but make them interesting
with on/off pressure and the use of toned areas where possible.

Horses and Ponies

The importance of detailed studies as part of a learning process continues with this theme, which considers the specific problems encountered in drawing horses and ponies. Even the largest breeds of dogs are small in relation to a standard pony – let alone a fully grown horse – and this can lead beginners to assume that the extra surface area can be depicted as flat or blank. To avoid this it is helpful to work from within the form, noticing the undulations and curving your pencil strokes to follow the contours.

When drawing animals and human beings it is vital to bear in mind the correct anatomy. The exercises I suggest show how you can depict the raised surface of veins, the strength of the muscles and bone structure under the surface of skin, and the relationship of hair to hoof.

Making a detailed rough will also be of help if you prefer a much looser approach to your final artwork. This choice tends to be a personal preference but try not to allow a loose style to become careless in application as this will inhibit your progress and improvement.

Typical Problems

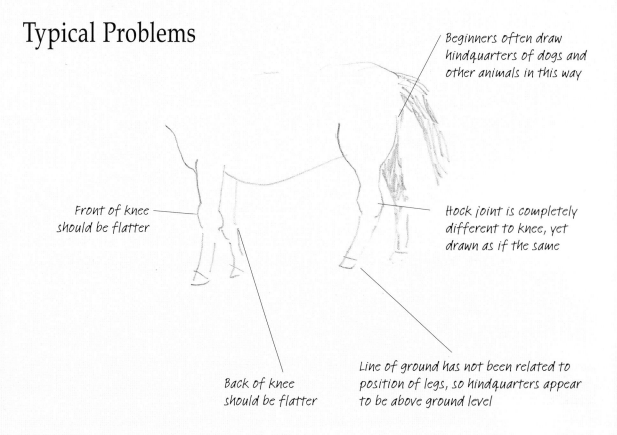

Beginners often draw hindquarters of dogs and other animals in this way

Front of knee should be flatter

Hock joint is completely different to knee, yet drawn as if the same

Back of knee should be flatter

Line of ground has not been related to position of legs, so hindquarters appear to be above ground level

Solutions

Legs

5B graphite pencil
on copier paper

Using a clear black-and-white photograph
and producing a photographic representation
is a good way to gain an understanding of
form and to learn how to tone up to, and
around, light areas.

Exercises:

(a)

(a) Areas of
smooth tone
either side of
a white strip.

(b)

(b) Tone
with flat,
then curved
strokes.

(c)

(c) Combine
the two
smoothly.

(d)

(d) For the
shadow side of
leg, define the
shape, then
gently shade
away.

(e)

(e) An exercise
to help
understand
hoof structure.

Guidelines dropped
from contact points
ensure that lower
parts of legs are
placed correctly

The small arrows
indicate the
consideration
given to the
direction of form

Negative shapes
are as important
as legs themselves

Drawing shows
how first rough
sketch is laid out

Dark grass behind
encourages light forms to
stand forward

Think your way through the hoof/hair
structure of the foal's foot in a similar
way to that used for the mushroom
cap/stalk on page 17.

Typical Problems

Drawing details gives an opportunity to look into the subject more deeply and to work out how line and tone may be developed together. Look closely and try to give an impression of all the 'ins and outs'. Your first attempts may not appear accurate, but, with practice, patience and perseverance – and determination – they will improve.

The nostril has been reduced to a simple oval – since this area is so complex it is a good idea to practise drawing it alone, noting all the intricacies

Lines do not relate to shape of nostril – and are usually lower

An attempt has been made to correct first shape, but both have been drawn heavily – if first attempt had been drawn very lightly, alterations could have been made over top with more pressure

Noseband drawn as if it cuts in to bone, not resting on it

Bit does not appear to be in horse's mouth

Solutions

Noses

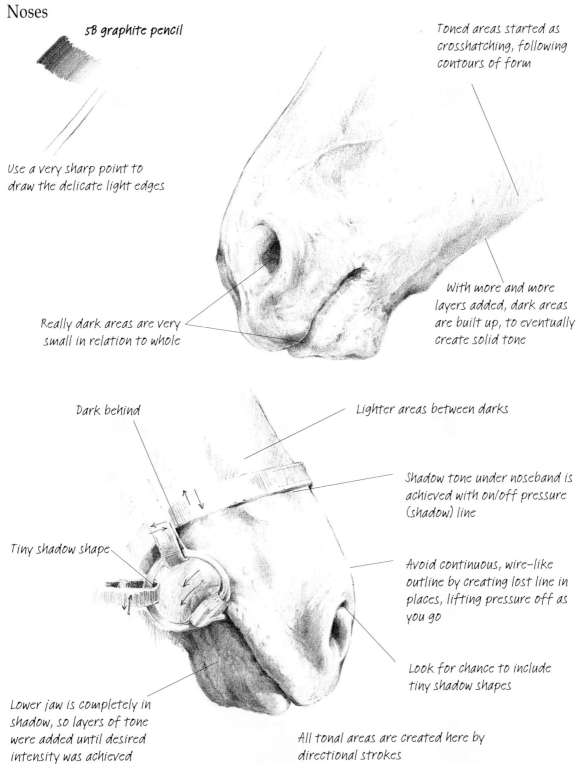

5B graphite pencil

Use a very sharp point to draw the delicate light edges

Toned areas started as crosshatching, following contours of form

Really dark areas are very small in relation to whole

With more and more layers added, dark areas are built up, to eventually create solid tone

Dark behind

Lighter areas between darks

Shadow tone under noseband is achieved with on/off pressure (shadow) line

Tiny shadow shape

Avoid continuous, wire-like outline by creating lost line in places, lifting pressure off as you go

Look for chance to include tiny shadow shapes

Lower jaw is completely in shadow, so layers of tone were added until desired intensity was achieved

All tonal areas are created here by directional strokes

Typical Problems

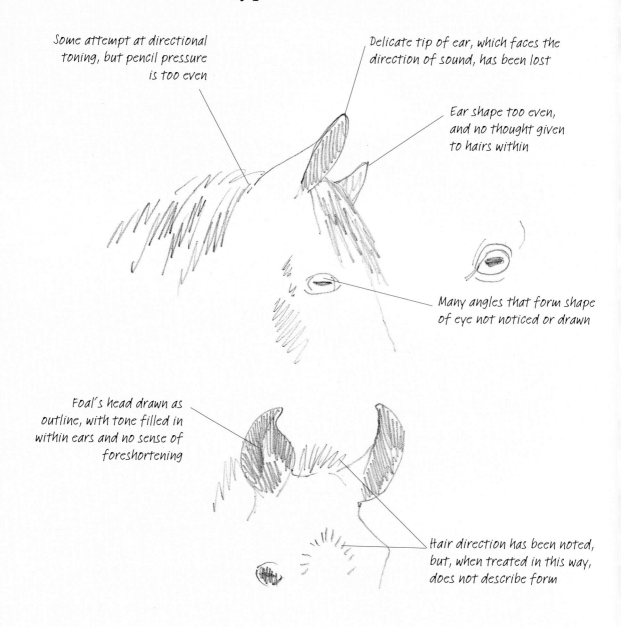

Some attempt at directional toning, but pencil pressure is too even

Delicate tip of ear, which faces the direction of sound, has been lost

Ear shape too even, and no thought given to hairs within

Many angles that form shape of eye not noticed or drawn

Foal's head drawn as outline, with tone filled in within ears and no sense of foreshortening

Hair direction has been noted, but, when treated in this way, does not describe form

On page 117, I have drawn the foreshortened ear as a rough, with guidelines and other lines that indicate what I *feel* about what I see. My roughs tend to be a mass of thought lines as well as the lines and tonal shapes that build form. Try *thinking* your way into your drawings, rather than just copying an image.

Solutions

Heads

Horses' ears are very flexible, turning towards the source of sound as well as responding to mood and temperament

When you draw ears it is important to relate one to the other, even if they are facing in different directions

Always look closely at the eye and look for angles, rather than just drawing around the entire shape with a line

These lines on a rough indicate flat surface

Look at an eye in a photograph and see how many angles you can find, then you will know where to place them in your drawing. The arrows here show the angles I have noticed

Working from a photograph, I show below how we still use the guidelines and shapes between – in this instance to help indicate a foreshortened ear

Guidelines help correct position

Look for angles

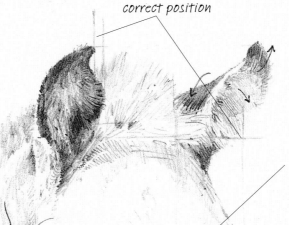

Draw directional lines to suggest form by imagining what it would feel like to pat this foal on the forehead

Demonstration

Pages of my sketchbooks have drawings of horses and ponies taken from life. Some are details of heads, legs and so on – whatever part I could put on paper before the animal moved. For this study, however, I used photographic reference alongside my sketches. It is gratifying when the animal looks up at the camera when the rest of its body is in a pleasing stance.

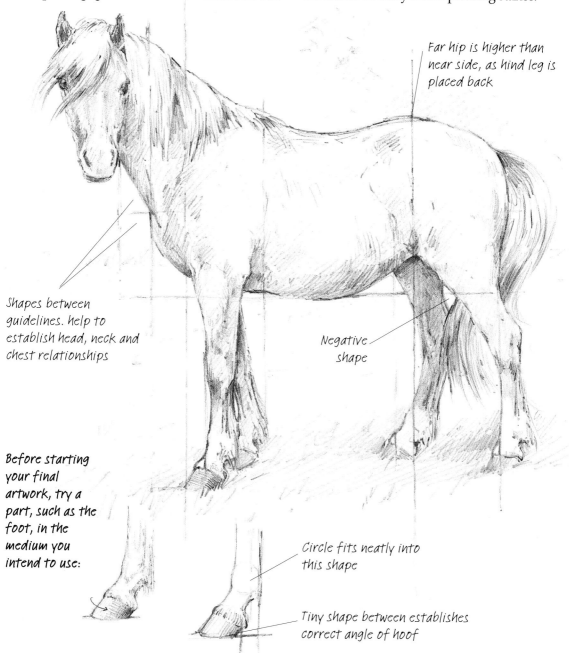

Far hip is higher than near side, as hind leg is placed back

Shapes between guidelines. help to establish head, neck and chest relationships

Negative shape

Before starting your final artwork, try a part, such as the foot, in the medium you intend to use:

Circle fits neatly into this shape

Tiny shape between establishes correct angle of hoof

Chestnut mare

Copper beech
watercolour pencil

Exercises for hair of mane:

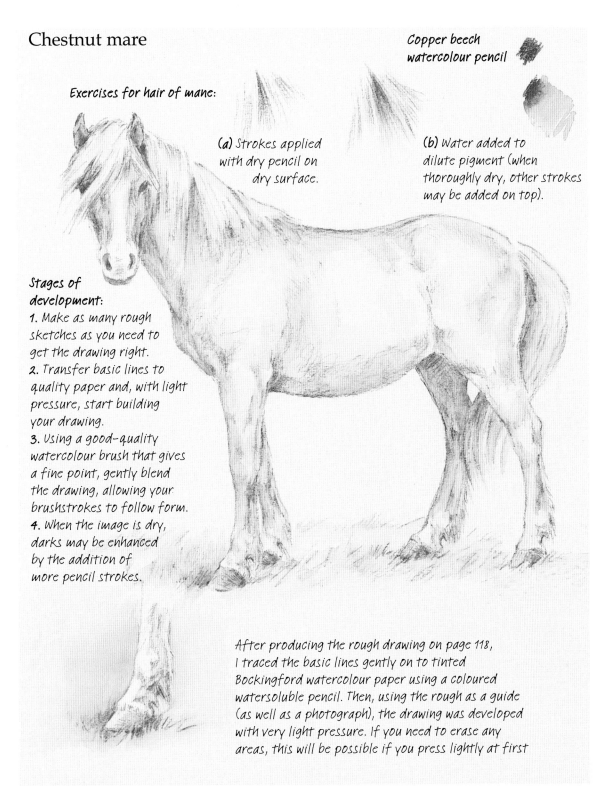

(a) Strokes applied
with dry pencil on
dry surface.

(b) Water added to
dilute pigment (when
thoroughly dry, other strokes
may be added on top).

**Stages of
development:**
1. Make as many rough
sketches as you need to
get the drawing right.
2. Transfer basic lines to
quality paper and, with light
pressure, start building
your drawing.
3. Using a good-quality
watercolour brush that gives
a fine point, gently blend
the drawing, allowing your
brushstrokes to follow form.
4. When the image is dry,
darks may be enhanced
by the addition of
more pencil strokes.

After producing the rough drawing on page 118,
I traced the basic lines gently on to tinted
Bockingford watercolour paper using a coloured
watersoluble pencil. Then, using the rough as a guide
(as well as a photograph), the drawing was developed
with very light pressure. If you need to erase any
areas, this will be possible if you press lightly at first

Portraits

For nearly all of us, the human face is one of the things we see most in our daily life, and is certainly what we use – from a very early age – to identify individuals and recognize them subsequently. Despite this, many beginners (and even some quite experienced artists) find drawing faces difficult and prone to causing problems. This is frequently because they try to bring out the character in a face without first observing it, both as a whole and in detail, and regarding it in the same way as a landscape or a still life, as a selection of lines, shapes and forms. Once again, practice, perseverance and patience are the guides.

In this theme I have chosen to cover angles, guidelines and the relationships with shapes between forms, rather than concentrating on individual features. The former has been the main consideration of my methods throughout this book, and it is important to understand how they may also be applied to the subject of the human face.

Depicting human features is best approached in the same way as drawing the features of animals – both involve close observation, thought and consideration of how to achieve an understanding of the form before you start to draw. Using angles and guidelines, you can position the features accurately in relation to each other, in the same way as other relationships. It is this aspect of placing the features correctly that is concentrated on, encouraging the observation of shapes between guidelines as well as negative shapes.

Typical Problems

The following are some of the problems that may present themselves to a beginner when attempting to draw from models (whether from life or using photographic reference) in poses similar to those on page 121:

1. Level of eyes. The cross superimposed on each study shows how you can overcome the problem of positioning eyes.

2. This also applies to the ears. Pay close attention to the angle at which the ears relate to the head of your particular model, as this is part of the person's character.

3. Use the vertical guidelines to position shadow lines between the teeth in relation to other features above – for example, nostril, part of eye, and so on.

4. Background. You will need to decide whether to use plain white paper or to tone behind. The latter may be done quite freely in order to allow the lighter form to stand forward.

5. It is probably better to understate eyebrows rather than make them too heavy – observe how they follow form and relate to the position of the eyes.

Solutïons

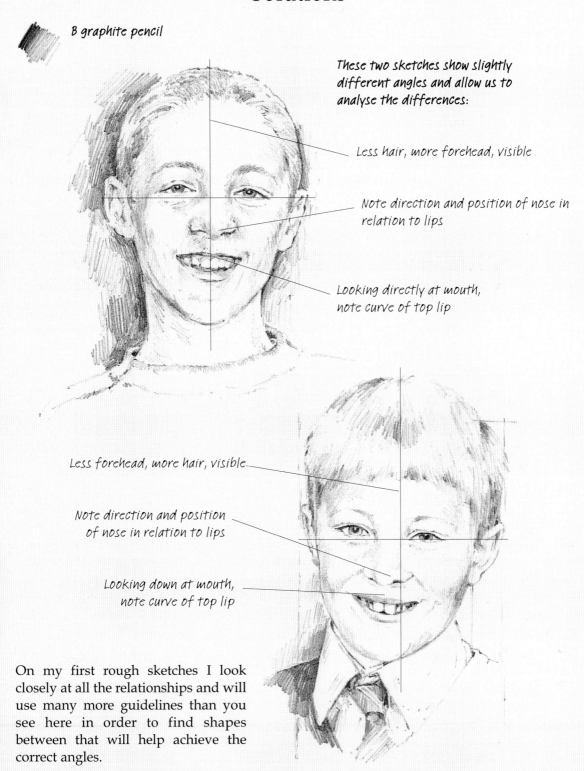

B graphite pencil

These two sketches show slightly different angles and allow us to analyse the differences:

Less hair, more forehead, visible.

Note direction and position of nose in relation to lips

Looking directly at mouth, note curve of top lip

Less forehead, more hair, visible

Note direction and position of nose in relation to lips

Looking down at mouth, note curve of top lip

On my first rough sketches I look closely at all the relationships and will use many more guidelines than you see here in order to find shapes between that will help achieve the correct angles.

Typical Problems

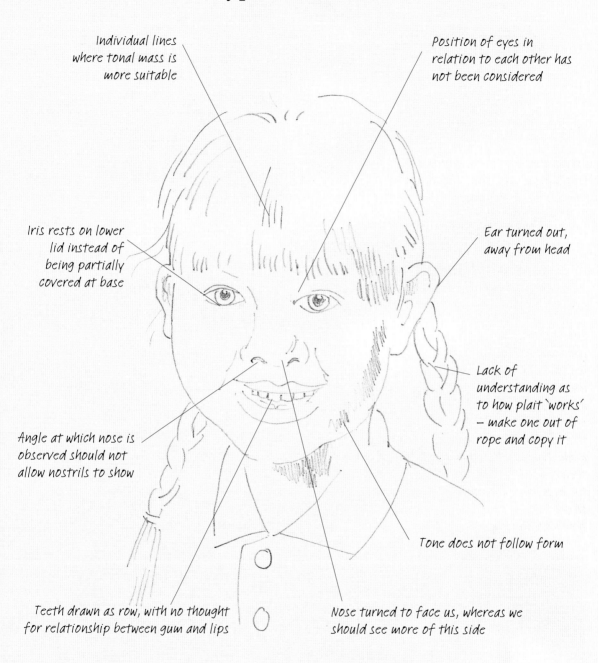

Individual lines where tonal mass is more suitable

Position of eyes in relation to each other has not been considered

Iris rests on lower lid instead of being partially covered at base

Ear turned out, away from head

Lack of understanding as to how plait 'works' – make one out of rope and copy it

Angle at which nose is observed should not allow nostrils to show

Tone does not follow form

Teeth drawn as row, with no thought for relationship between gum and lips

Nose turned to face us, whereas we should see more of this side

The positive shapes have been drawn rather than the negatives and other shapes between, which would have been far more helpful towards accurate placing – for example, between the side of the head/neck and the plait.

Solutions

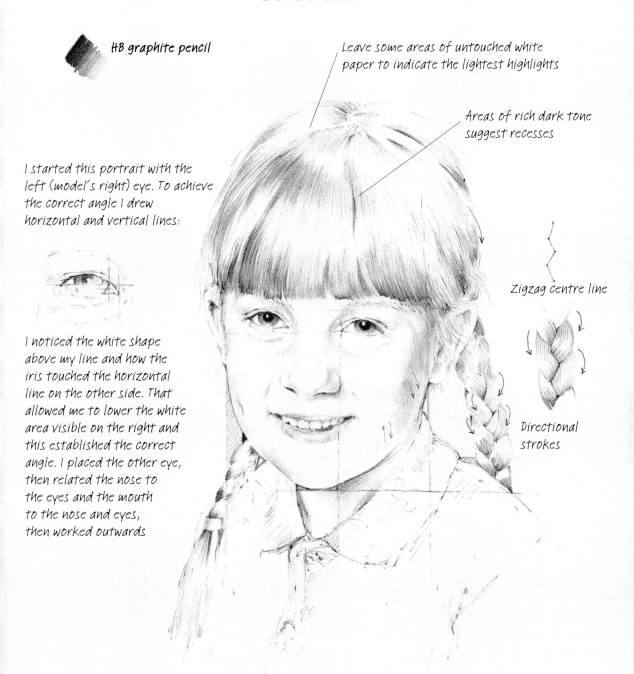

HB graphite pencil

Leave some areas of untouched white paper to indicate the lightest highlights

Areas of rich dark tone suggest recesses

I started this portrait with the left (model's right) eye. To achieve the correct angle I drew horizontal and vertical lines:

Zigzag centre line

I noticed the white shape above my line and how the iris touched the horizontal line on the other side. That allowed me to lower the white area visible on the right and this established the correct angle. I placed the other eye, then related the nose to the eyes and the mouth to the nose and eyes, then worked outwards

Directional strokes

If you can place one of the smaller (yet most important) areas correctly you can then use guidelines from that area outwards into the rest of the portrait. Notice all the tiny (yet vital) shapes between – including them in your drawing will help you place areas correctly.

Typical Problems

Both studies are of the same person, but not enough care has been taken over certain characteristics, so they look like different people. With just a few guidelines (horizontal and vertical) to help, greater accuracy could have been achieved with the main features.

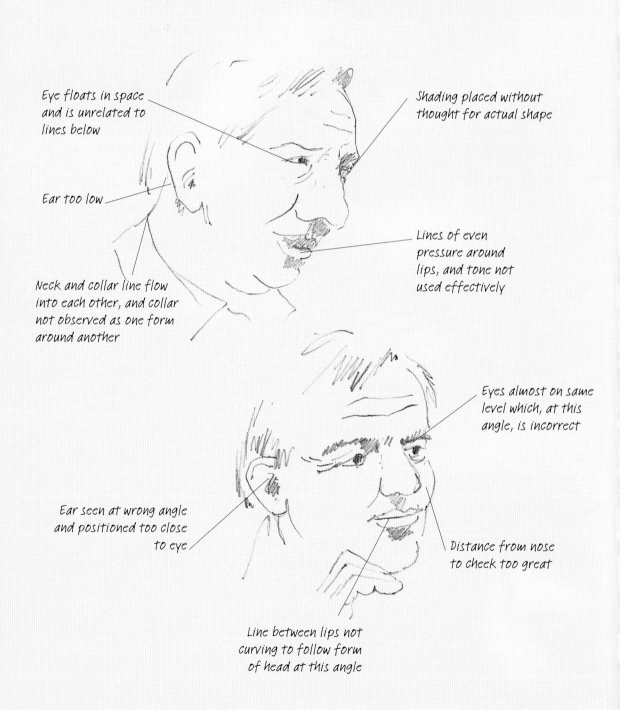

Eye floats in space and is unrelated to lines below

Shading placed without thought for actual shape

Ear too low

Lines of even pressure around lips, and tone not used effectively

Neck and collar line flow into each other, and collar not observed as one form around another

Eyes almost on same level which, at this angle, is incorrect

Ear seen at wrong angle and positioned too close to eye

Distance from nose to cheek too great

Line between lips not curving to follow form of head at this angle

Solutions

9B graphite pencil

Expressions are as a result of reactions.
The expression on this face is a reaction to
strong sunlight while deep in thought,
whereas below it is more that of interest
in a subject being observed:

Note dark shadow shapes

Shadow line

Lost line

Dark
behind

Shape
between

This is in a more free style than
the studies on pages 121 and 123,
for which I chose a much softer
pencil, as I wanted to accentuate
the darks

A slightly three-quarter view is more
interesting than a profile and offers a
chance to use shapes more effectively
when placing angle of nose, eyes and so on

Demonstration

I usually draw the guidelines and other areas emphasized here very lightly on my paper, as I feel my way into the portrait. I have made them dark on this page in order that you can see my thoughts on paper.

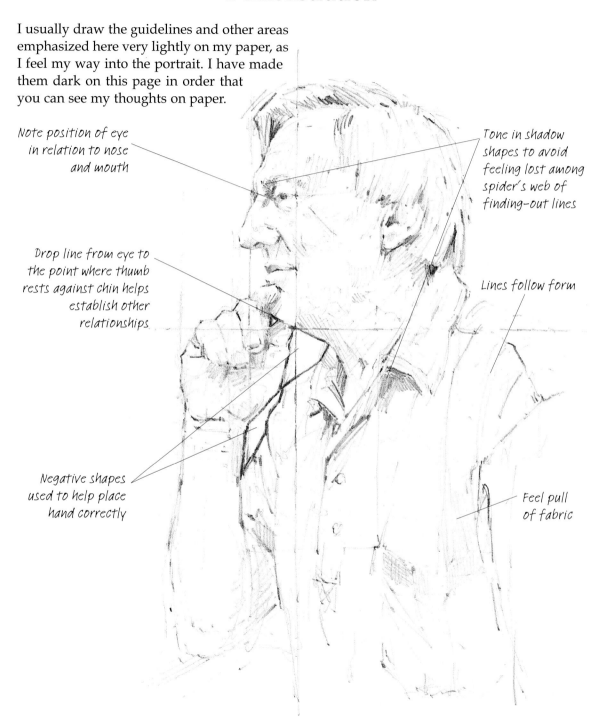

Note position of eye in relation to nose and mouth

Tone in shadow shapes to avoid feeling lost among spider's web of finding-out lines

Drop line from eye to the point where thumb rests against chin helps establish other relationships

Lines follow form

Negative shapes used to help place hand correctly

Feel pull of fabric

This demonstration contains wandering lines that follow form, darks behind, shapes between, negative shapes, lines of varied pressure, and the alternate use of chisel and pointed side of pencil.

Michael Pibworth

There is more chance of you achieving a likeness in your first portraits if you draw someone who is familiar to you. I asked my husband to pose for this study.

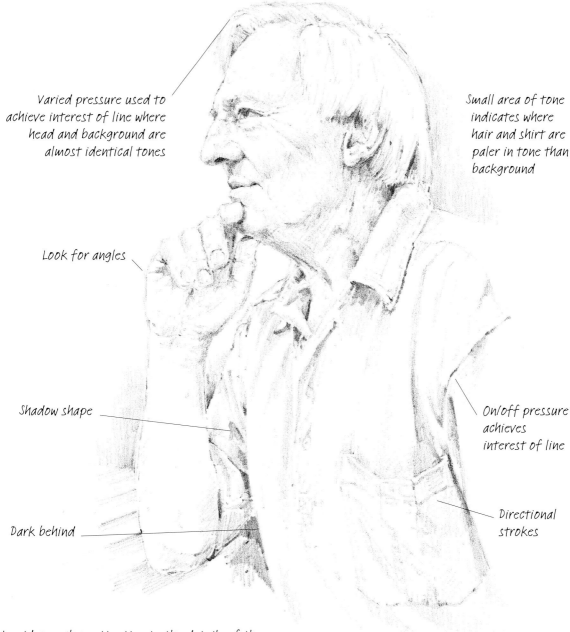

Varied pressure used to achieve interest of line where head and background are almost identical tones

Small area of tone indicates where hair and shirt are paler in tone than background

Look for angles

Shadow shape

On/off pressure achieves interest of line

Dark behind

Directional strokes

I paid very close attention to the details of the features and the folds of the collar, pocket and so on, allowing the pencil to travel more freely over other areas

Index